Assyrian Sculpture

JULIAN READE

D0770156

Published for
the Trustees of the British Museum by
BRITISH MUSEUM PUBLICATIONS

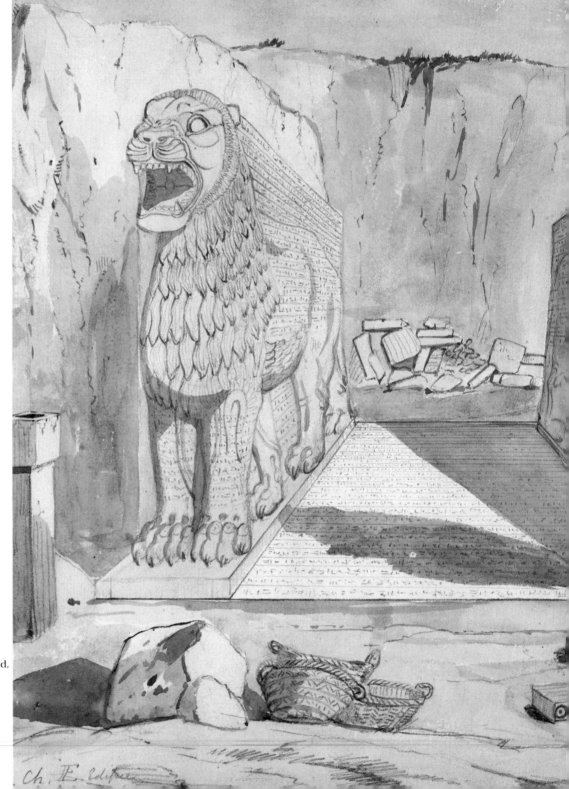

THE TRUSTEES OF THE BRITISH MUSEUM acknowledge with gratitude the generosity of **THE HENRY MOORE FOUNDATION** for the grant which made possible the publication of this book

Photo Acknowledgements

All photographs unless otherwise specified in the Key to Illustrations have been produced by the Photographic Service of the British Museum and the work of James Hendry is particularly acknowledged.

© 1983 The Trustees of the British Museum
Reprinted 1984, 1986, 1987

ISBN 0 7141 2020 0

Published by
British Museum Publications Ltd,
46 Bloomsbury Street,
London WC1B 3QQ

Designed and produced by Roger Davies

Set in Zapf Book Light

Printed in Italy by New Interlitho

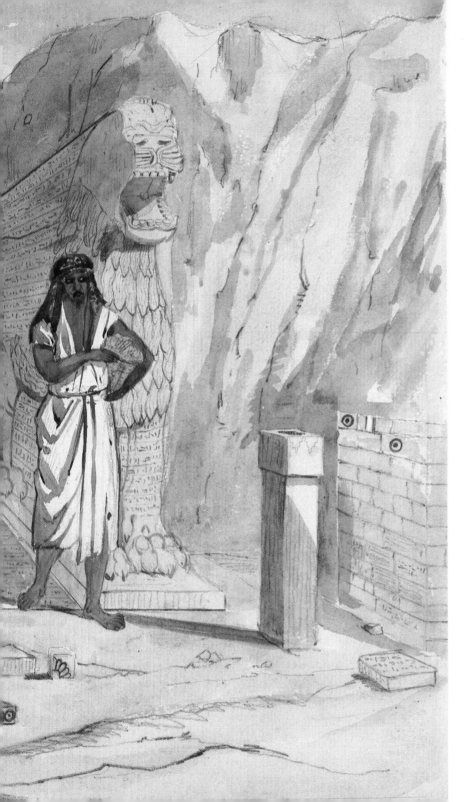

Contents

Preface

This book is intended both as a guide to the Assyrian sculptures in the British Museum, which has the best collection of them in the western world, and as a general introduction to the subject, placing the sculptures in their archaeological and historical context. I have chosen some of the finest and most representative groups to discuss in greatest detail; there are more which could not be accommodated, and other aspects of them which there has not been space to consider. To some extent the order of discussion and illustration differs from the arrangement of the sculptures in the galleries, but individual pieces may be located by reference to the map and key printed at the end.

Assyrian sculptures are now widely dispersed. There are collections in the major museums of Paris, Berlin, New York, Chicago and many other cities, large and small. The most important groups outside London, however, are naturally in the Republic of Iraq, partly in the museums of Baghdad and Mosul and partly in their original positions, on the walls of the palaces where they were carved.

In writing this account I have occasionally made use of work done jointly some years ago by Dr David Frankel and myself, and I acknowledge his contribution with gratitude.

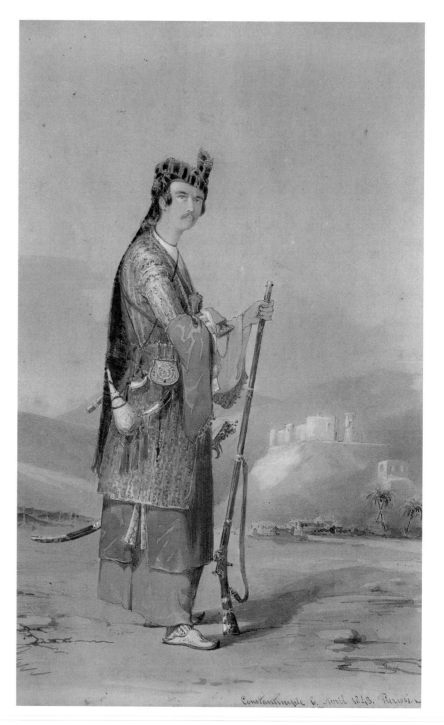

1 Henry Layard in Persian dress, Constantinople, 1843.

The Discovery of Assyria

During the nineteenth century most of the Middle East belonged to the Turkish Ottoman Empire, with its capital at Constantinople. Travel outside the main cities was difficult and often dangerous, and whole areas of the countryside were liable to be controlled by people who, if not in active rebellion against central government, were effectively independent. This was no place for the casual tourist, but there were occasional visitors from western Europe, merchants, diplomats, or simply travellers, for whom Turkish Arabia was something more than a name on the map. Among them were men who recognized that, in these wastes, were buried some of the oldest civilizations of the world.

The Bible was a starting point, with stories familiar to every European at the time. The Garden of Eden was thought to have lain somewhere in Mesopotamia, between the Tigris and Euphrates, rivers that retained their ancient names. The site of Babylon was visible by the Euphrates, not far from Baghdad, and there was argument over which of the vast ruins in the neighbourhood might represent the fabulous tower of Babel. Nebuchadnezzar was remembered as a king of Babylon who had captured Jerusalem, and there were Biblical references to yet earlier kings, such as Sennacherib, who had come from a land called Assyria to invade and subjugate Palestine. The Assyrian capital had been Nineveh, and this name too survived. The ruins of the city lay beside the Tigris, opposite modern Mosul, in what is now northern Iraq.

Other hints came from Classical historians, more widely read then than now. These spoke of the Persian empire, in constant contact with the Greeks during the fifth and fourth centuries BC. Again there were references to the far older civilizations of Babylonia and Assyria. The Persian city of Persepolis was known too, with standing monuments inscribed in a strange and long undeciphered form of writing, cuneiform. This script, or at least something recognizably related, was also to be seen on bricks from Babylon. They suggested by their very existence that much more might yet be learned about ancient Mesopotamia.

The first man with the leisure and determination to undertake serious archaeological research in this part of the world was Claudius Rich, British Resident in Baghdad from 1808 till 1821. He mapped Babylon, and gathered together antiquities that were to form the nucleus of the British Museum's Mesopotamian collection. In 1820 he visited Mosul, and while exploring Nineveh, he learned of 'an immense bas-relief, representing men and animals, covering a grey stone of the height of two men', which had been dug up some years previously. He records that 'all the town of Mosul went out to see it, and in a few days it was cut up or broken to pieces.' Among the souvenirs that Rich brought back from Nineveh were two small fragments of carved stone, tangible evidence of such sculptures. He died shortly afterwards, and it was not until 1836 that the account of his visit to Nineveh was published; but within twenty years of the book appearing, the Assyrian ruins had produced things that even an imaginative man like Rich might have found hard to credit.

In 1842 Paul-Emile Botta was French consul in Mosul. He devoted some of his time to digging for antiquities, starting with two trenches on Kuyunjik, largest of the Nineveh mounds. These mounds, unlike those of Babylon which contained palaces and temples of good baked brick and had consequently been quarried for centuries, appeared at first sight to be little more than piles of earth, with occasional traces of stone structures, and it was by no means clear how the digging should proceed. Nonetheless Botta's workmen persevered, carefully retaining every fragment of brick and alabaster, until a passing farmer suggested one day that, if they wanted sculptured stones, they would do far better to try his own village, Khorsabad, where there were plenty of them. Botta at first was inclined to disbelieve him, but a short trial was dramatically successful. The workmen found themselves excavating, a few feet down, a complicated series of rooms and corridors that were lined, or panelled, with tall slabs of gypsum. The surface of the slabs had been burned, and they were disintegrating, but Botta

could see that every one had been decorated with sculptures in low relief, showing processions and scenes of warfare. Many too had inscriptions in the cuneiform script, so that they evidently dated from a very early period, though how early was far from obvious.

What Botta had found was in fact a palace of the Assyrian king Sargon II, built around 710 BC. Some years were to pass before the inscriptions could be read, but the importance of the discovery was clear. Reports on Botta's work began to appear in the press in May 1843, and the French government allocated funds to pay for the research, besides sending out an accomplished artist, Eugène Flandin, to draw the crumbling sculptures. Work proceeded, with one interruption, until October 1844, when Botta concluded that there was no more to be found. Some of the better preserved sculptures were chosen for removal to Paris, but their transport caused enormous difficulty. They had to be carried to Mosul on home-made carts, with 500 or 600 men attempting to haul the biggest of them. Then they were loaded on to rafts and floated down the Tigris, almost 1000 miles, to the port of Basra. It was December 1846 before they reached France.

Though the Louvre naturally has the finest collection of Khorsabad sculptures in Europe, some of them nonetheless reached London. It seems that, when the French abandoned the site, private merchants scavenged there, and many fragmentary sculptures were bought by the British Museum as early as 1847. By far the most imposing pieces from Khorsabad in London, however, are two human-headed winged bulls, with attendant genies, which the 2 French had had to leave behind because they were too heavy. In 1849 Henry Rawlinson, the British Resident in Baghdad, who played a major part in the decipherment of cuneiform, bought these from the French consul, and resolved the problem of their weight – about sixteen tons each – by having them sawn into several bits. In the same year the English archaeologist, Henry Layard, himself excavated briefly at Khorsabad, and came away with a fine sculptured slab which is also at the British Museum.

The great bulk of the British Museum collection of Assyrian sculptures came from independent British excavations elsewhere. While Botta had been the pioneer, Layard and his colleague Hormuzd Rassam, succeeded by William Loftus, worked far more extensively at two sites, Nineveh and Nimrud, which turned out to be considerably more interesting. Khorsabad had been a one-period site, built by Sargon and left virtually unoccupied after that king's death. Nimrud, in contrast, was the Assyrian capital for some 150 years, immediately before the move to Khorsabad, and Nineveh was the capital for almost a century afterwards. The two between them concealed several successive royal palaces, all lavishly decorated with stone sculpture.

Layard had been born in 1817 and at the age of sixteen, after a cosmopolitan education, obtained a respectable place as a trainee in a solicitor's office – almost the classic starting-place, it was to be observed, for an adventurous youth. In 1839, after qualifying as an attorney, he set out overland in order to work in Ceylon. He never arrived. After two years in some of the wildest parts of the Middle East, he became a 1 roving agent attached to the embassy at Constantinople. In the autumn of 1845, the ambassador, Sir Stratford Canning, impressed by Layard's descriptions of Nimrud, agreed to pay the costs of a tentative excavation. It was a place, not far from Mosul, which Layard had first visited in 1840, and he had long dreamed of working there; he had even urged Botta to try the site, but fortunately for himself this did not happen. Layard, now aged twenty-eight, had all the qualifications necessary in those days for an archaeologist in Mesopotamia: he was an educated man, endowed with courage, intelligence, determination, and physical strength, who had wide experience of dealing and communicating with Arabs and Turks. Over the next few years he needed these qualities, and demonstrated plenty more beside.

On 8 November 1845, with tools made secretly to avoid local jealousies, Layard set off down the Tigris from Mosul, by raft; the story was that

2 Human-headed winged bull and attendant genie. From Khorsabad, reign of Sargon II, about 710 BC.

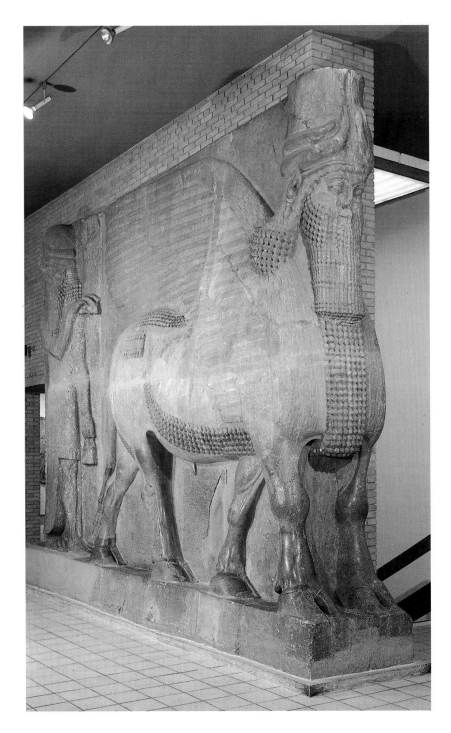

he was going to hunt boar. Instead, he landed close to the great mound of Nimrud, and the very next day began excavations, employing local tribesmen. Within a few hours they had begun to uncover walls, panelled with stone slabs inscribed in cuneiform, that had belonged not to one palace but to two. During the following three weeks inscribed slabs continued to appear, and at last, on 28 November, there were sculptured slabs too. In the next four months Layard's workmen discovered a whole series of sculptured rooms.

The technique of excavation, once one sculptured slab had been located, was relatively simple. The walls of the palaces themselves had been built originally of sun-dried mud-brick, a material which is strong and versatile when new and dry, but which turns back to earth when exposed unprotected to the elements. The palace rooms had accordingly filled with mud-brick that had fallen from the tops of the walls when the buildings were abandoned, and the stone panelling, which covered the walls to a height of 2.5 metres or more, remained in position with earth both in front of it and behind. The excavator had merely to decide which side of the slabs faced into a room, not always obvious when some of them had been re-used the wrong way round, and then trench along the walls, round the corners and through the doors, following wherever the stone panelling led. This was the method adopted by Botta at Khorsabad and by Layard at Nimrud; at both sites the sculptured slabs were fairly close to the surface of the ground, and deep excavation 3 was unnecessary.

The excavation of the Nimrud palace of Ashurnasirpal II (883–859 BC), finest of Layard's early discoveries, caused bewilderment in the neighbourhood. At one stage the head of a colossal human-headed winged lion was revealed, upright in the side of a trench. The local sheikh with half his tribe hurried to the spot, but Layard records that it was some time before he could be 'prevailed upon to descend into the pit, and convince himself that the image he saw was of stone. "This is not the work of men's hands", exclaimed he, "but of those infidel

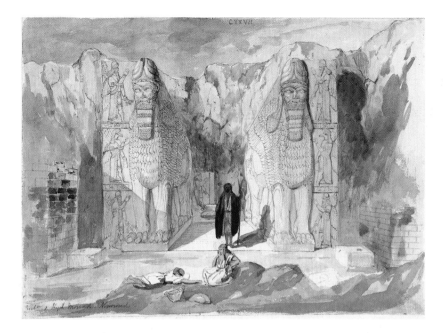

3 Entrance to the shrine of Ninurta, Nimrud, built by Ashurnasirpal II about 865 BC. Cooper's watercolour of Layard's excavations, 1850.

giants of whom the Prophet – peace be with him! – has said that they were higher than the tallest date tree; this is one of the idols which Noah – peace be with him! – cursed before the flood." In this opinion, the result of a careful examination, all the bystanders concurred.' Meanwhile one of the workmen had rushed away to Mosul to report that Layard had excavated Nimrud himself, a hero from the dawn of history, and the local governor commanded that the remains, whatever they might be, should be treated with all due respect. On another occasion the governor and his retinue came to visit the site, and various speculations on the colossal figures ended with an assertion that they were the work of the Magi, and were 'to be sent to England to form the gateway of the palace of the Queen'.

This last suggestion was not so wide of the mark, since Canning, at Constantinople, was in the process of getting official approval both for the continuation of the work and for the shipment of all the sculptures back to England. The Ottoman government at the time had little interest in antiquities as such. Even in the 1870s

British archaeologists in Assyria were liable to find themselves working under regulations that had been drawn up to control commercial mining, and sometimes had to pay a percentage tax on the value of what they exported. For Layard, nonetheless, there were serious obstacles; they consisted of the sheer quantity of sculptures uncovered, his limited funds, the perils of the raft journey to Basra, and the scarcity of ocean-going ships visiting Basra anyway. The result is that, though the British Museum now contains much the best collection of Assyrian sculptures from the work of Layard and his successors, there are many which were either left behind or allocated to other individuals and institutions, ultimately reaching countries all over the world.

Layard went on excavating during the spring and summer of 1846 as often as conditions allowed, and it began to be appreciated that his discoveries were at least as important as Botta's. Canning now succeeded in arranging for the British government to take over responsibility. Effectively the British Museum paid back Canning's money, and Layard became their agent instead. By November he found himself better off financially but burdened also with a fresh set of instructions: he was to organize the excavations, draw all the sculptures, copy the 4 inscriptions on them, make casts of them, and send them to England, reburying any that could not be removed. His only literate assistant was Rassam, a young brother of the British Vice-Consul in Mosul. Despite his remarkable range of duties, with employers in London who can have had very little idea of what was involved, Layard determined to justify the trust that had been placed in him. Over the next five years, as archaeologist and author, he laid the foundations of his distinguished later career as a politician and diplomat.

At Nimrud, during late 1846 and the first half of 1847, the discoveries continued. There was a third palace, that of Tiglath-pileser III (745–727 BC), the sculptures of which had been taken down and piled in a courtyard, awaiting re-use in the palace of Esarhaddon (680–669 BC); and there was the Black Obelisk of Shalmaneser III 12

4 Layard at Nineveh. A drawing by the Rev. S.C. Malan, who visited the excavations in June, 1850.

(858–824 BC), a complete free-standing monument with carvings on all four sides and with an inscription which proved invaluable in the process of deciphering cuneiform. Yet far more important, in the long run, was Layard's discovery that the mound of Kuyunjik at Nineveh, unsuccessfully trenched by Botta, did indeed contain Assyrian remains of the kind desired. The way Layard found them is recounted with characteristic self-assurance: 'An acquaintance with the nature and position of the ancient edifices of Assyria, will at once suggest the proper method of examining the mounds which enclose them. The Assyrians, when about to build a palace or public edifice, appear to have first constructed a platform, or solid compact mass of sun-dried bricks, about thirty or forty feet above the level of the plain. Upon it they raised the monument. . . . Consequently, in digging for remains, the first step is to search for the platform of sun-dried bricks. When this is discovered, the trenches must be opened to the level of it, and not deeper; they should then be continued in opposite directions, care being always taken to keep upon the platform. By these means, if there be any ruins they must necessarily be discovered, supposing the trenches to be long enough; for the chambers of the Assyrian edifices are generally narrow, and their walls, or the slabs which cased them if fallen, must sooner or later be reached.'

Using this technique, in the mound of Kuyunjik, Layard within a few days located what was probably the largest of all Assyrian royal palaces, the one built by Sennacherib (704–681 BC). It too was sculptured; though fire had damaged or virtually destroyed a large proportion of the decoration, much was still visible. The presence of later remains above Sennacherib's palace meant that the system of trenching could not be continued indefinitely; there was too much earth to remove. Layard therefore resorted, in the end, to tunnelling along the walls of the building, cutting vertical shafts at intervals to provide light, air, and a means of extracting soil. It must have been dangerous work, but perhaps not very difficult, since his men followed the sculptured walls, leaving the interiors of the rooms unexcavated.

By June 1847, Layard's funds were exhausted, and he left for home. A few workmen remained to keep possession of Kuyunjik, in case rival antiquaries appeared on the scene. During 1848 it must sometimes have seemed that the British would withdraw from Assyria altogether, but the gradual arrival of Layard's finds in London, and the publication of his brilliant book *Nineveh and its Remains*, ensured public interest, even enthusiasm.

In October 1849, Layard was again at Mosul, accompanied this time by a professional artist, Frederick Cooper, and he resumed work at Sennacherib's palace and at Nimrud. Before he finally left Mesopotamia, in April 1851, he reckoned that he had exposed nearly two miles of sculptured walls in Sennacherib's palace alone; this building also produced the library of Sennacherib's grandson, Ashurbanipal (668–627 BC), an accumulation of cuneiform texts on

9

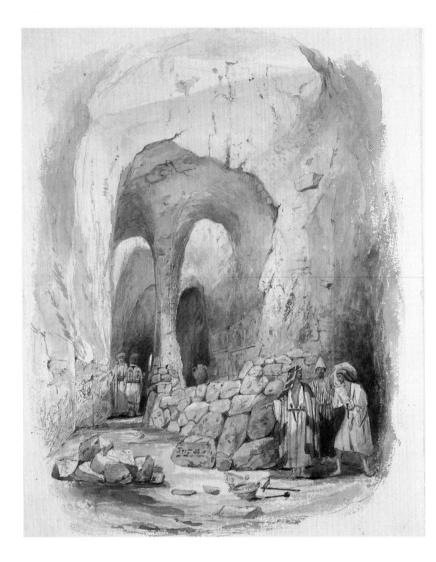

5 A tunnel dug through Sennacherib's palace, Nineveh, painted by Cooper about 1850.

walls of Nineveh, on which was built a village and a mosque containing the reputed tomb of the prophet Jonah. Layard and others have excavated small areas of this mound, and it is known to contain a palace, at least partly sculptured, of Esarhaddon; but religious objections have always prevented its systematic exploration.

After Layard's departure Rassam and others continued the excavations at Nineveh and elsewhere. The results, however, if compared with Layard's, must have seemed paltry and discouraging; the sponsors in England could hardly now be satisfied with occasional statues and a steady stream of small objects and cuneiform tablets. There was again a possibility that the sites would be abandoned, and in 1853 a private society, the Assyrian Excavation Fund, was set up in London to ensure continuation of the work. Rawlinson, controlling British operations from his office in Baghdad, even assigned half the mound of Kuyunjik to a newly appointed French Consul, Victor Place, who had been sent to resume work at Khorsabad. Then, in December 1853, just as the British Museum funds were coming to an end, Rassam hit on what was in some respects the finest sculptured palace of all. Built by Ashurbanipal, about 645 BC, its remains lay on the northern side of Kuyunjik, relatively close to the surface.

It seems that Rassam had had some inkling of what was to be found in this area, but had been prevented from working there openly since it was in the part of the mound which Rawlinson had handed over to the French. Place had not taken advantage of the offer, and Rassam anyway thought that Rawlinson had not been entitled to make it; it was an embarrassing situation, and Rassam decided that his only hope was to work secretly, by moonlight. On the third night, when news of the clandestine operation had already reached Mosul, and Rassam anticipated that he might at any moment be interrupted, his workmen abruptly found that one of their trenches was in the middle of a sculptured corridor: a fall of earth revealed, in an instant, the greater part of one of the slabs showing Ashurbanipal's large-scale

which much of our knowledge of ancient Mesopotamian literature and science is based. During the same expedition Layard located some of the temples of Nimrud, and investigated many other sites, including one that was later to be identified as Ashur, the first Assyrian capital city, but hopes of further sculptured palaces were disappointed; these were confined to Nimrud, Khorsabad, and Nineveh. Particularly tantalizing was a second mound, within the

79

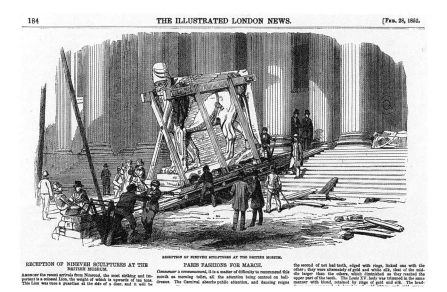

RECEPTION OF NINEVEH SCULPTURES AT THE BRITISH MUSEUM.

RECEPTION OF NINEVEH SCULPTURES AT THE BRITISH MUSEUM.

Amongst the recent arrivals from Nimrud, the most striking and important is a colossal Lion, the weight of which is upwards of ten tons. This Lion was once a guardian at the side of a door, and it will be

PARIS FASHIONS FOR MARCH.

Commencer à commencement, it is a matter of difficulty to recommend this month as morning toilet, all the attention being centred on balldresses. The Carnival absorbs public attention, and dancing reigns

the second of net had teeth, edged with rings, linked one with the other ; they were alternately of gold and white silk, that of the middle larger than the others, which diminished as they reached the upper part of the teeth. The Louis XV. body was trimmed in the same manner with blond, retained by rings of gold and silk. The head-

6 A human-headed winged lion, from Ashurnasirpal's palace, Nimrud, arriving at the British Museum.

lion-hunt, the most celebrated of Assyrian sculptures. This find apparently eliminated the need for secrecy, 'because it was an established rule that whenever one discovered a new palace, no one else could meddle with it, and thus, in my position as agent of the British Museum, I had secured it for England.'

Before long, as usual, many more sculptured rooms had emerged, but the palace was still not completely cleared when Rassam had to leave in May 1854. At first Rawlinson enlisted Loftus, of the Assyrian Excavation Fund, to continue the work; but then more funds suddenly arrived from the British Museum, and two rival British missions found themselves excavating the same palace. At one stage Loftus, who had come on sculptures lying at a lower level than those in the main palace, was digging trenches that threatened to undermine those of the British Museum workmen. Eventually good sense prevailed, and the two groups merged, with Loftus directing the work in the field. Sculptures found by the Assyrian Excavation Fund, and presented by it to the British Museum, include nearly all the small-scale hunt scenes of Ashurbanipal.

Meanwhile Place was engaged at Khorsabad.

The presence of this French expedition, probably the first in Mesopotamia to be furnished with a camera, was in one way providential, as a French ship had been chartered to carry their discoveries home. The British Museum, on the other hand, was not only short of money to pay for shipment, but had also realised that it could not conceivably accommodate the huge new collection of Ashurbanipal sculptures. Rawlinson therefore reached, with Place, what seemed an eminently satisfactory agreement. The French ship would carry to Europe all the sculptures which the British required; and in return the French were allowed to take any of the remainder for themselves.

While the British share was to arrive safely, disaster overtook the French. The authorities in Paris, like those in London, had little understanding of local conditions in Mesopotamia, and insisted on recalling Place before his sculptures had reached Basra. His rafts had to pass through territory which was in open rebellion against the Ottomans, and though the local people had no use for old stones, there were other valuables aboard: personal possessions, some bales of silk that had been smuggled on without Place's knowledge, even the ropes, skins and timber of which the rafts were constructed. The convoy was repeatedly plundered as it approached Basra in May 1855, and most of the sculptures sank in the river. They must be widely scattered, and attempts to recover them have not succeeded; many of them must have been severely damaged at once by exposure and the abrasion of the current, since the stone of which they are made is soluble in water, but maybe something worth having survives beneath the silt.

With the close of excavations in 1855, the hectic Heroic Age of Assyrian archaeology ended. Scholars and interested members of the public naturally remained aware of the sculptures on display in Europe, but more exciting fresh discoveries were to be made in the written cuneiform documents, vast numbers of which were by now awaiting study. Periodically, from 1872, the British Museum sent out expeditions to get more of them, and occasionally new

7 A gateway at Khorsabad, built about 710 BC; it was flanked by colossal sculptures, and decorated above by an arch of glazed bricks. This photograph, one of the first to be taken in Assyria, shows the French excavations directed by Place in 1852–3.

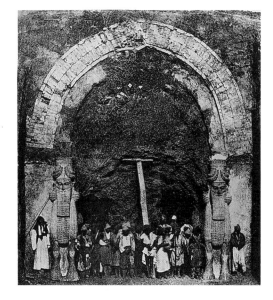

sculptures emerged; in 1878 Rassam also excavated, at the site of Balawat near Nimrud, two sets of gates decorated with embossed bronzes. But there were no more sculptured palaces. By 1900 German scholars had taken the lead in Assyrian studies, and Walter Andrae's 1903–1914 excavations at Ashur, the city that had baffled Layard, were enormously productive; yet even here sculptures were scarce. Meanwhile those that had been left in position, at Nimrud, Nineveh, and Khorsabad, were suffering various fates. The British Museum had given instructions that slabs not removed should be reburied, but that did not prevent dealers from re-excavating some of them. A large bull exposed at Nineveh is said to have been sold by the local governor, around 1900, to be burned and turned into plaster. In 1927, when American scholars visited Khorsabad, they saw a sculptured head being used in the village as a chopping block, and their subsequent work there showed that the slabs drawn by Flandin in 1844 were generally in a sad state of repair.

The break-up of the Ottoman empire after 1918, and the emergence of successor states, including Iraq and Syria, led to a great expansion of archaeological work. One major discovery, made by a French team under François Thureau-Dangin, was a provincial Assyrian governor's palace at Til-Barsip in Syria; this had been decorated with wall-paintings, cheap alternatives to the sculptured slabs of metropolitan Assyria. In 1949 a British expedition originally led by Max Mallowan returned to Nimrud, and among its last discoveries in 1962 was a stone throne-base carved with a scene hitherto unparalleled in Assyrian art – a peaceful summit-meeting between the kings of Assyria and Babylon; this is now in the Iraq Museum, Baghdad. For the most part, however, twentieth-century work in the field has enlarged our knowledge of Assyrian sculpture without producing dramatic surprises. The most important development in recent years has been the re-excavation, by the Iraqi authorities, of parts of the palaces of Ashurnasirpal and Sennacherib; visitors to Nimrud and Nineveh can now see a few complete slabs standing, with massive effect, in their original positions.

At the same time scholars have been attempting to reintegrate, on paper, the schemes of architectural decoration into which the sculptured slabs, now dispersed, once fitted. The great pioneers here were Eckhard Unger and Ernst Weidner, but it was Cyril Gadd who revealed through his entertaining book *The Stones of Assyria*, quite how much information was present in the form of unpublished drawings made by Layard and his colleagues. Whereas the French government had issued eight magnificent volumes on the work at Khorsabad, Layard had to rely on private backing to publish even a selection of his drawings, and it would have saddened but hardly surprised him to learn that the rest were to remain largely neglected for well over a century. The first complete catalogue of all the sculptures and drawings of sculptures from a single palace, prepared by Margarete Falkner with the co-operation of Dr Barnett of the British Museum, appeared in 1962. Since then the burden and challenge of interpreting the sculptures, and defining their historical and artistic significance, have been taken up by many hands. Each new generation should have something fresh to add.

The Sculptures in their Setting

The Assyrian sculptures mostly date from a period, roughly 900–600 BC, during which the small kingdom of Assyria grew into an empire that dominated the entire Middle East from Iran to Egypt and then, under assault from an alliance of Medes and Babylonians, disappeared altogether. This was the last stage of a historical process which can be traced back to the years around 1400 BC, when a succession of able kings transformed the old trading city and cult-centre of Ashur into a first-rate political power. Ashur was the name both of the city and of the city-god. From this is derived the name Assyria, describing the lands beside the Tigris in northern Iraq; the ancient name may survive, by an odd twist, in that of the modern state of Syria, occupying an area which once belonged to the Assyrian empire. 8

In many respects Assyrian civilization was an offshoot of Sumerian and Babylonian, which had first developed to the south-east, on the great flood-plain of the lower Tigris and Euphrates. The Assyrians, whose official language was a dialect of Akkadian closely related to that spoken in Babylonia, accepted this ancient culture as their own; its most obvious manifestation, perhaps, was the elaborate cuneiform script, which expressed sounds by various combinations of basic wedge-like shapes. At the time that Assyria emerged as an independent power, however, there were other states to the west, the empires of the Mitannians, Hittites and Egyptians, which were in their way no less sophisticated than the eastern Kassite empire of which Babylon was then part. Assyria was to become the political heir of Mitanni, and remained open to influences from the west; it is from this direction that the very idea of decorating palaces extensively in stone is likely to have come.

The Assyrian heartland consists of rolling plains, with many agricultural settlements. There are mountains to the north and east, 9 semi-desert to the south and west, and the inhabitants of these fringe areas have always been inclined to raid or infiltrate the rich lands in between. Peace and prosperity have depended on the existence of governments strong enough to cope with these persistent threats, and Assyrian kings were judged by their success in doing so. The king was not a mere secular ruler; he was high priest of the god Ashur, and his traditional duty, owed both to his god and to his subjects, was to maintain and furthermore to extend the borders of the land of Ashur, to impose the yoke of Ashur on lands beyond the pale. Yet the more successful the kingdom was, the more its problems multiplied: every time a neighbouring land was conquered and incorporated, there turned out to be another unconquered land beyond. A casual glance at the Assyrian sculptures in the British Museum suggests that this was a state dedicated whole-heartedly to war.

In fact, of course, Assyrian foreign policy differed in different reigns. If some kings were imperial megalomaniacs, others were subtle realists who mixed diplomacy with deterrence, and were only too happy to encourage the establishment of buffer states along their frontiers. The obligation to extend the kingdom became in time far less pressing than problems of internal administration and security. Monuments that were designed for public display rather than interior decoration show the king to some degree as a man of action but more as the ideal archetypal Mesopotamian ruler, responsible custodian of the land and people entrusted to him by God.

This aspect of the royal personality is most clearly illustrated in a type of monument, the stela, which appears in its classic form from the reign of Ashurnasirpal II onwards. Stelas were 10 erected inside and outside temples, both within the empire and in neighbouring lands which acknowledged Assyrian hegemony. Most examples show the king, framed in an arched panel, before the symbols of his principal gods. The king is distinguished, above all, by his royal hat; its shape, seen from the side, is that of a truncated cone, with a diadem around it and a smaller cone or knob on top. This hat, with slight variations, was worn by all Assyrian kings; something not unlike it, a fez, had been an item of court dress in earlier centuries, but now it was reserved for the king alone. The king

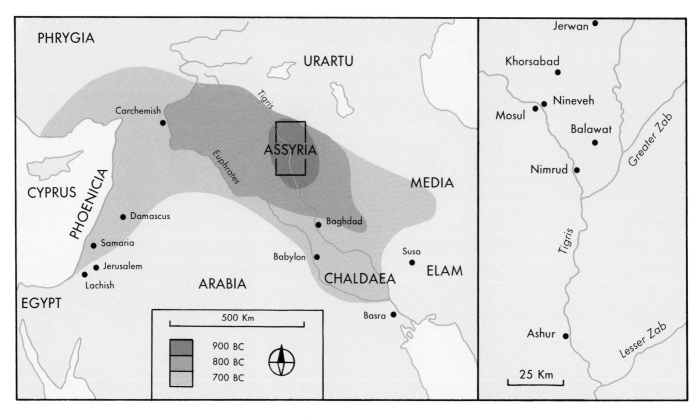

PHRYGIA

URARTU

Tigris

Carchemish

Euphrates

ASSYRIA

CYPRUS

PHOENICIA

MEDIA

Damascus

Baghdad

Samaria

Babylon

Susa

Jerusalem

CHALDAEA

ELAM

Lachish

ARABIA

EGYPT

Basra

500 Km

900 BC
800 BC
700 BC

Jerwan

Khorsabad

Nineveh

Mosul

Balawat

Greater Zab

Nimrud

Tigris

Ashur

Lesser Zab

25 Km

8 *Left*: The expansion of the Assyrian empire, between 900 and 700 BC. *Right*: the heartland of Assyria.

9 Northern Assyria, with the mountains of Urartu beyond.

10 Stela of Ashurnasirpal II (883–859 BC), from Nimrud. The king holds a mace, **symbol of authority**, in his left hand, and extends the right, with forefinger outstretched as if he has just snapped his fingers, in a gesture of respect and supplication towards the symbols of five gods. The helmet decorated with horns represents the supreme god, here naturally Ashur; the winged disc, a symbol that probably originated in Egypt, stands for the sun god, Shamash; the crescent, within a full circle, is the emblem of the moon god, Sin; the undulating line or fork is the thunderbolt of the storm god, Adad; and a star, the planet Venus, signifies Ishtar, goddess of love and war. The king wears a row of similar symbols on his chest, with a Maltese cross instead of a winged disc for the sun.

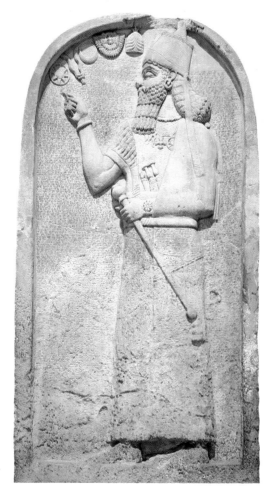

wore a simple short-sleeved dress that reached to his ankles; this was covered by a more elaborately decorated garment the top end of which was pulled over the left arm, round the back, and then forwards over the right shoulder to be fastened to the belt in such a way that the right arm remained free. The sculptures do not always represent this garment consistently, but there are enough examples for us to be sure that it worked on this principle; one can see front and back together on a free-standing statue of Ashurnasirpal II. Like the royal hat, clothes of this kind were worn by royalty alone. They represented the king in his role as high priest of Ashur, and are most common in ritual scenes.

This stela scene was also represented in panels which were cut on cliffs and rocks at distant points reached by the Assyrian kings on campaign. Cuneiform inscriptions on the rock panels, as on the stelas, described the glory of Ashur embodied in the achievements of his representative, the king; it was the Assyrian way of asserting their dominion, planting the flag. One of the embossed bronzes from Balawat has an illustration of a stela actually being 11 carved, at the source of the Tigris in 852 BC. A workman, busy with hammer and chisel, receives directions from a scribe, one of a class of people whose duties included ensuring that the king was always represented in the correct manner. Being eminently practical people, the Assyrians realized that these rock carvings were liable to be mutilated as soon as the army left, and many were hidden in inaccessible places; there are probably some still awaiting discovery. At least once, however, a rock stela was carved in a prominent place immediately beside the monument of a far older, Egyptian king. Belonging to an ancient culture, the Assyrians were fully aware of the tides of history; wishing to protect his own immortal memory, an Assyrian king would normally respect the monuments of his predecessors so long as this could be done without undue inconvenience to himself.

Another type of monument was the royal statue. Few of these have survived, and here as often we have to reckon with the probability that what has survived is a small unrepresentative selection of what once existed. Those we have are stone, and there may have been many in more precious materials that were destroyed at the fall of the empire in 614–612 BC. Again these monuments presented an image of the king as a dignified monarch, far removed from the rough and tumble of war or daily life. The finest example we have, showing Ashurnasirpal *back* without his hat, was erected in the shrine of *cover* Ishtar at Nimrud, where it stood in respectful but confident anticipation of divine favour.

A more variable image is presented by the

15

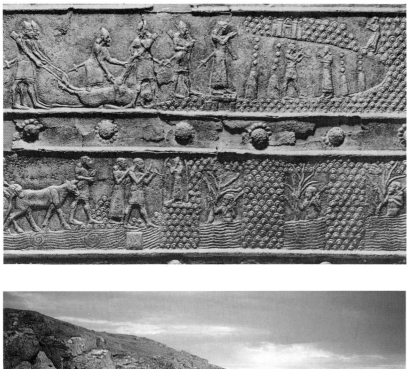

11 *top*. Shalmaneser III's visit to the source of the Tigris in 852 BC. Workmen, supervised by courtiers, are cutting commemorative panels on the rocks. Meanwhile animals are brought for sacrifice, and men with torches explore the cave from which the river issues.

at his feet. Another early example, the White Obelisk, is decorated instead with a great variety of narrative scenes: the king at war, the king hunting, the king receiving tribute. We recognize here, despite their miserable state of preservation, the themes and compositions which are to reappear in the palace art of kings from Ashurnasirpal II onwards. In a largely illiterate society, these illustrations were evidently more potent than inscriptions alone, and scraps of evidence suggest that comparable scenes had been not uncommon, on small objects and textiles, with many reminiscences of the international artistic repertoire, heavily influenced from Egypt, of the period 1500–1200 BC.

Two further obelisks, the Rassam Obelisk of Ashurnasirpal II and the Black Obelisk of Shalmaneser III, both of which stood in a public area, insist rather on the pacific nature of the ninth-century Assyrian empire. They show the desirable after-effects of successful power politics. In both the king appears receiving the tribute of a submissive world. Many of the tributaries come from the wonderfully rich and luxurious states of Syria and the Phoenician coast, bearing among other things exotic gifts acquired through their extensive trading networks: Assyrian demand probably played a major part in the development of Mediterranean trade in the centuries to follow. Other men bring horses from Iran, a type of tribute that grew increasingly important with the development of cavalry.

The structural decoration of the Assyrian temples, with which these single free-standing monuments were usually associated, was largely based on principles which can be traced back far into the past of Mesopotamia. For instance, a traditional method of decorating a temple entrance, and providing magical protection against any malign influences that might approach, was to put figures of lions on either side. In Babylonia, where stone was scarce, these were of baked clay, or of metal overlaid on a cheaper core material like bitumen. In the west stone was more readily available and was frequently used, but the Assyrians came to use

obelisks which were also placed in relatively public places. The Assyrian obelisk does not culminate in a point like the true Egyptian sort, but has a stepped top recalling the appearance of a Mesopotamian temple-tower. The earliest known dates from the reign of Ashurbelkala (1073–1056 BC); called the Broken Obelisk because much of the shaft is missing, it has on the front a carved panel which shows the Assyrian king with divine symbols, as on the stelas, but also with small-scale captives leashed

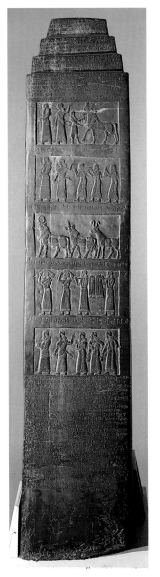

12 The Black Obelisk of Shalmaneser III, from Nimrud, about 825 BC.

13 *far left below*. Natural outcrop of gypsum, the stone from which most of the Assyrian sculptures were carved, at 'Ain Taya, western Assyria.

it on a larger scale than had been done anywhere, at least in Mesopotamia, beforehand. An imposing example is a monolithic lion from one side of the doorway into Ashurnasirpal's Ishtar shrine at Nimrud.

It is possible that stone animals of this size were introduced to Assyria by Tiglath-pileser I (1114–1076 BC), who must have become familiar during his western campaigns with the stone architectural decoration of Hittite cities like Carchemish. The Germans found some fragments of his sculptures at Ashur, but they were made of basalt, a hard black volcanic stone which had to be imported into Assyria. Basalt continued to be employed there, as in a seated statue of Shalmaneser III, but it cannot have been easy to transport large pieces in any quantity. At Ashur also, from an early date, varieties of local limestone had been used for structural purposes, especially at the base of walls, but its quality was generally mediocre. What Ashurnasirpal did, when about 879 he moved his capital to Nimrud, was to panel the bottoms of the mud-brick walls of many important structures with slabs of a particular kind of stone whose exceptional characteristics had not, apparently, been appreciated by earlier kings.

This stone, often called Mosul marble or 13 alabaster, is a variety of gypsum which is commonly found close to the surface in parts of Assyria though not, perhaps, close to Ashur itself. It slowly dissolves in water, so prominent outcrops have a weak and powdery exterior, but a little deeper down there are solid deposits which can be cut into huge blocks. It is a relatively soft stone, but far from brittle, and can be carved in the finest detail. It was evidently ideal for architectural decoration so long as it was adequately protected from the weather. It was accordingly used by subsequent Assyrian kings in the interiors of the state apartments of their palaces. Sometimes it also appears in positions where it must have been exposed to torrential winter rains, and we presume that it was then coated with layers of varnish or, certainly in some cases, paint.

Carvings of Sennacherib, made about 700 BC, illustrate the excavation of this stone from an open quarry. Once a block had been extracted, 14 apparently with picks, it could be cut by the great iron saws which appear in another 15 Sennacherib scene; examples of such saws have been excavated at Nimrud. Colossal animals will then have been roughed out, to 50 reduce their weight, but the final carving was done after they had been set in position, and sometimes it was never quite finished. The same is true of the far more numerous wall-slabs, generally about two or three metres high, which were placed as panelling on the walls. These slabs often had royal titles engraved on their backs, a protection against oblivion, but it would have been impracticable to carve the fronts before they had been finally erected. The bases of the slabs rested on a bed of bitumen which facilitated fine adjustments, and they were then secured to each other, and probably to the wall behind, with lead dowels and with clamps. Only then could the carving begin. The great majority of the surviving Assyrian sculptures are wall panels of this kind, carved in low relief with a range of narrative and other scenes.

As the creation of a sculptured palace was an exceptional event, which did not normally happen more than once in a king's reign, if at all, there will have been no fixed procedure in executing the work, but we can see that many individuals were involved and that there were several tiers of responsibility. At the top stood the king. Written documents testify to the close interest which kings took in the progress of buildings, such as palaces, which had a commemorative as well as a practical function. We may occasionally detect royal influence indirectly in the choice of subject-matter, and in the quality, of carvings on slabs placed close to the throne or in the king's private apartments; in one or two cases the alteration of specific details may tentatively be ascribed to royal intervention. The general design of the palace and its decoration was probably entrusted to a committee of senior officials under royal supervision. At least one of them will have been experienced in magic, knowing how to ensure

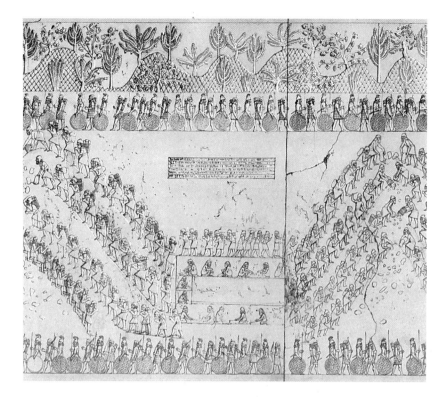

that the magical figures to be carved on the walls were sited to the maximum protective effect; we can observe consistent patterns in the ways in which these figures were arranged even though the precise reasons may elude us. In the same way both large-scale formal sculptures and small-scale narrative scenes were sited with discrimination. Each palace had characteristics of its own, but the internal arrangements were never haphazard.

Once the general scheme of interior decoration had been decided and the slabs were in position, the preliminary physical work in different areas had to be done, and the workmen were divided into several teams. This is most clearly demonstrable in Ashurnasirpal's palace at Nimrud, where several rooms were decorated with scenes of identical type executed in divergent ways. The procedure seems to have been that in each area one man drew or incised the main outlines in his own consistent style: for instance, the magical figures are thickset in one room, slim in another. The final cutting and polishing of the slabs was then done by an army of artisans, Assyrians or foreigners, using chisels to begin with, then finer tools. The quality of the final work, even sometimes within the confines of a single slab, was very variable. Any cuneiform writing that was required was then added by scribes, again using drawing or incision, and the signs were cut out by masons who are themselves likely to have been illiterate; this is the kind of operation we see in the Balawat bronze. Some sculptures from the seventh century suggest mass production by more rough and ready techniques, without the systematic use of preliminary guide-lines and consultation. One Sennacherib fragment even shows a scene that was carved a second time, 16 higher up, because the first version had been too low down on the wall.

The Assyrian sculptures, for the most part, being wall-decoration, are not so much sculptures conceived in three dimensions as two-dimensional drawings translated into low relief. This applies even to free-standing figures, which tend to be uncomfortably square rather than naturally rounded at the corners, and may also

14 Quarry scene, about 700 BC, with prisoners under heavy guard extracting a block of stone that will be carved into a human-headed winged bull for Sennacherib's palace at Nineveh.

15 Men carrying saws, picks, and shovels, from a series showing the transport of a colossal human-headed winged bull from the quarry to Nineveh, about 700 BC.

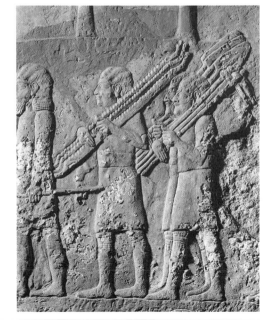

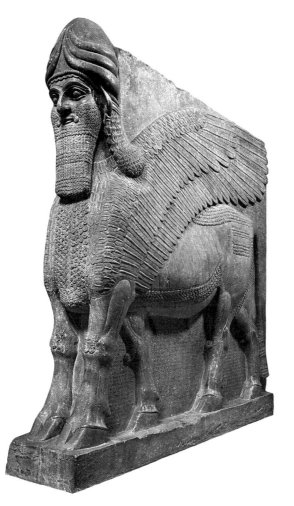

17 Human-headed winged bull from Ashurnasirpal's palace at Nimrud, about 865 BC.

16 Part of a siege scene, with archers and slingers, from Sennacherib's palace at Nineveh, about 700 BC. This scene had originally been cut at a slightly lower level on the same slab, and extensive recarving was necessary to adjust its height.

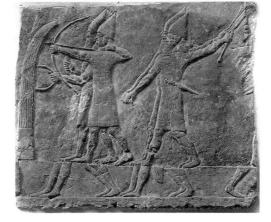

account for one of the odder features of the early colossal gateway figures such as the Ishtar Temple lion and the human-headed winged lions and bulls from Ashurnasirpal's palace at Nimrud. If one looks at one of these monsters from the side, one sees that it has four legs, striding purposefully forward. If one moves to look at it head-on, from the front, it has two front legs at rest. Both views in isolation are satisfactory and logical, as the figure might have been drawn by an artist looking at it either from one direction or from the other. The three-quarter viewpoint, in contrast, with both front and side visible at once, shows an animal that has not four legs but five. The effect is successful, 17 and goes unnoticed at a glance. These monstrous figures, combining as Layard suggested the intellectual powers of man with the speed of birds and the strength of lions or bulls (while some which had fish-skin cloaks were evidently at home in water too), can manage happily with one superfluous leg. There may also have been a rational explanation, that the animals were shown in two successive postures, both standing and walking. Yet, for the Assyrians, there was something unsatisfactory about these five-legged creatures; colossi of Sennacherib and later kings have to make do with four.

The men responsible for the Assyrian sculptures were much influenced by existing techniques of wall-painting. Some of the earliest to survive are on glazed tiles from the reign of 18 Tukulti-Ninurta II (890–884 BC), Ashurnasirpal's father. They are in much the same style; instead of cut relief there are heavy outlines circumscribing individual features. From the seventh century, when a few of the stone sculptures besides colossi are in somewhat higher relief, we have some clay plaques which may have been sculptors' models, and these exhibit something not far off a three-dimensional approach. A stone bas-relief now in Ankara, from a Hittite state then under Assyrian domination, actually experiments with a three-quarter view. On the whole, however, the Assyrian sculptors seem to have remained content, in so far as they had any choice, with a convention that did not preclude experiment in

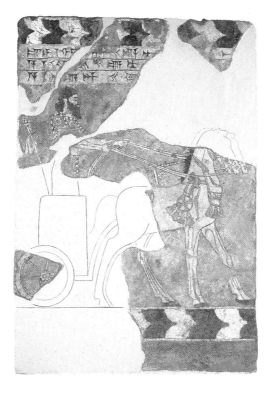

18 Glazed tile from Ashur, about 885 BC.

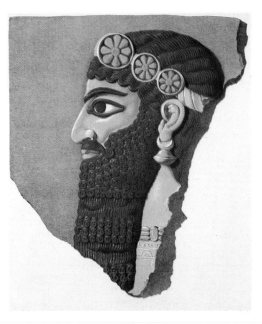

19 Head of genie, with colours restored from original traces. From Nimrud, about 865 BC.

other directions, and it is important that we should not see them as striving towards the perspective illusions fashionable in fifth-century Greece.

As the sculptures were closely related to paintings, they were naturally painted. The Ashurnasirpal sculptures, on the whole the best preserved we have, had at the time of excavation extensive traces of black paint on the hair, white on the whites of the eyes, red in various places; the palace of Sargon at Khorsabad included scenes in which the vegetation was found to be painted blue, possibly a decayed copper green. Moreover, the closer we look at the sculptures, the more detail we see: thus the robes of the king and courtiers are often incised with a great variety of tiny scenes which must surely have been set off by the use of paint or overlay in precious metal. It is nonetheless puzzling that more traces of painting have not been recorded. Otherwise the palaces were colourful places, with wall-paintings on the plastered walls above the sculptured panelling. Occasional fragments of these paintings have been found, and they included comparable scenes. Paintings in the main royal palaces of the ninth century seem to have had a rich blue ground, with details mainly in black, white, and red; later there was a wider range of colours. There were also panels of painted bricks, glazed, which decorated exterior walls, brightened the crenellations, or lined the arches above major gateways. Colour at ground-level was provided by rich carpets, some of which were imitated in stone. We can hardly imagine the sculptures as dull virtually monochrome bands in deliberate tasteful contrast with their gaudy surroundings.

Examples of another kind of architectural decoration that deserves brief notice have reached us only by peculiar good fortune. The palace and temple of a small town near Nimrud, now called Balawat, were set alight by enemies about 614 BC before they had been efficiently looted, and three sets of doors have been found there, two of which are now in the British Museum. The horizontal cross-struts of the leaves were covered by bands of embossed

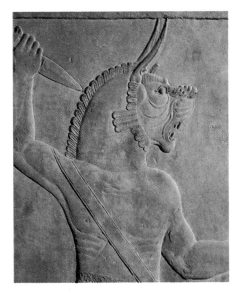

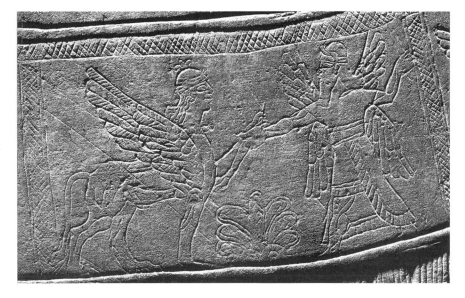

20 Genie, with traces of red paint surviving. From Nineveh, about 645 BC.

21 A winged lion with a woman's head, grasped by a genie: one of the more informal small-scale scenes incised, like embroidery, on the clothes of many figures in Ashurnasirpal's palace at Nimrud, about 865 BC.

22 Reconstruction, published by Layard, of Ashurnasirpal's throneroom at Nimrud. Details are wrong, but the scene as a whole carries conviction.

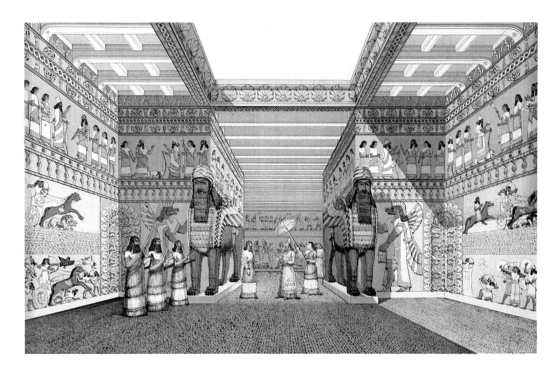

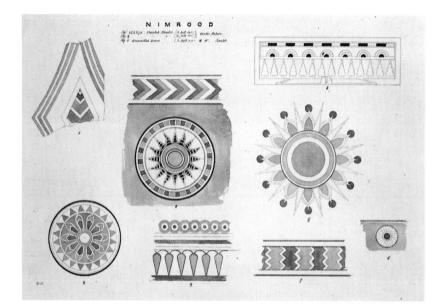

23 Details of wall-paintings and (top right) a glazed brick found at Nimrud, about 9th–8th century BC. Painting by William Boutcher, about 1854.

24 Stone door-sill carved as a carpet. From the palace of Ashurbanipal, Nineveh, about 645 BC.

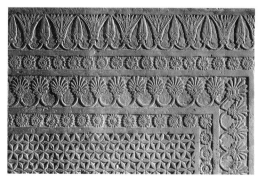

bronze, dating from the reigns of Ashurnasirpal II and his son Shalmaneser III. The scenes represent military and hunting expeditions and provide us with small-scale versions of the types of narrative also found in stone sculpture. Probably there were other such doors in all the main palaces.

There are several levels at which the Assyrian sculptures may be appreciated. They can be seen, some of them, as works of art though the word 'art' in its current meaning embodies an aesthetic concept foreign to the culture that created them; obviously there were men we

could call artists, who knew their craft supremely well and were responsible for stylistic and technical innovation, but the work of art, if we use this term, was the unitary scheme of palace decoration of which the extant sculptures formed only part. We may speak, more legitimately perhaps, of the masterful way in which these sculptures fulfilled and still fulfil the purpose for which they were designed, above all the glorification of the Assyrian monarchs. We can trace the increasing skill and sometimes restraint with which the sculptors delineated the features of a world on which Ashur imposed his just rule. Or we can look closer, and be grateful for the painstaking representations of things like architecture and jewellery, harness and devices for lifting water, that offer a vivid insight into the material culture of western Asia in the ninth–seventh centuries BC.

Another approach is to study, through these largely narrative scenes, the mentality of the Assyrian rulers and courtiers for whom they were created. We discern then that the Assyrian state, as presented here, was reasonable and consistent in its policies. A basic assumption was that territory once fully conquered on behalf of Ashur was inalienably Assyrian; there was no warfare there, only the benefits of Assyrian rule under the calm ruler illustrated in the stelas. Internal rebellion was unthinkable; of course there were rebellions from time to time, and disputes over succession to the throne drastically weakened the empire, but they were not a suitable theme for narrative art though sometimes indirectly reflected there. The only plain exception is in the case of Babylon, which always received peculiar treatment. Most of the narrative scenes therefore represent a world beyond the Assyrian pale: some foreigners dutifully bring tribute and are treated with respect, others have to be subdued by force. The worst treatment is reserved for those who have previously accepted Assyrian hegemony, thereby avoiding full incorporation in the empire, but have then repudiated it. Such scenes, displayed in public reception rooms, should have had a salutary deterrent effect on visiting foreign dignitaries, besides providing

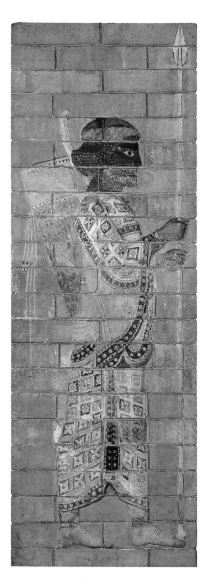

25 Modern reconstruction of a pair of gates made about 845 BC for a royal building at Balawat. They were of wood, with strips of embossed bronze at intervals. They were not hinged, but attached to vertical posts that turned on pivot-stones.

26 Glazed brick panel, showing an archer, from the palace of the Persian king Artaxerxes II (404–359 BC) at Susa.

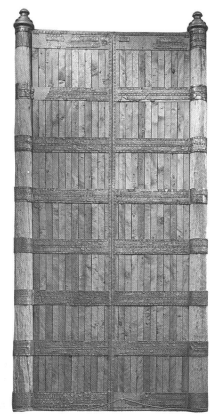

assurance and entertainment for members of the Assyrian court. There seems no reason to suppose that the Assyrians were any more violent than their less successful contemporaries, or than imperial nations at other times; what disconcerts us in many of these scenes is their honesty.

As the scenes represented Assyrian triumphs, however, there was no room for defeat. The king is not a remote and superhuman character, he and his soldiers are no less vulnerable than the enemy; but it redounds to the Assyrians' credit that somehow only the enemies die. The sculptures in fact seem to be essentially trustworthy if schematic records of true historical events, but highly selective in what events they include. Yet while the Assyrians regarded opposition to their rule as incomprehensible and utterly unacceptable, they freely recognized that other peoples might have much to offer in other ways. Not only was great care taken in recording the dress and other distinctive characteristics of foreign people. Foreign technological, artistic, even religious practices were adopted in Assyria whenever they seemed advantageous, and the sculptures record the increasingly cosmopolitan nature of an empire that, towards the end of the seventh century, had unified the nations of the Middle East in a way never seen before. By the end the usual language in the streets of Nineveh was probably the widespread Aramaic rather than the local Akkadian. While political control passed through warfare first to Babylon and then to Persia, these successor states inherited a world that was largely the creation of Assyrian arms, and seem to have used Assyrian administrative techniques to hold it together. While the Assyrian palace sculptures had no immediate direct successors, Assyrian artistic traditions had been widely disseminated in other ways, partly through painted provincial palaces such as the one at Til-Barsip in Syria. The Medes of eighth and seventh-century Iran must have been familiar with such buildings, and so, through the Medes, were the Persians. We see, without surprise, reminiscences of Assyrian work on 26 the walls of Persepolis and Susa.

Ashurnasirpal at Nimrud

The ruins now known as Nimrud, where Layard began work in 1845, were once the Assyrian city of Kalhu, mentioned as Calah in the Bible. It was an ancient town, probably much neglected when Ashurnasirpal II chose it as his administrative capital in 879 BC. Centrally placed within the Assyrian heartland, it was nonetheless some distance from the major traditional cities of Ashur and Nineveh, and his choice of site enabled Ashurnasirpal to build what was virtually a new city, to his own specifications, without having to take continuous account of existing historic monuments and vested interests.

Nimrud lies beside the Tigris, about twenty miles downstream of Mosul. Its walls enclose an area of some 360 hectares (890 acres). A huge military arsenal and several large palaces or mansions have been found in the outer town, but the main royal buildings and palaces were on the 20-hectare (50-acre) citadel, a raised mound that overlooked the river. Work on these buildings lasted almost fifty years, under both Ashurnasirpal II and Shalmaneser III, and other buildings were added from time to time

until Sargon moved the capital to Khorsabad about 710 BC. About 670 BC Esarhaddon seems to have been in the process of moving the capital back to Nimrud, but his death brought this project to an abrupt end. So, for the last century of the Assyrian empire, Nimrud was no more than an important town, but it retained the imposing appurtenances of a former capital city.

A visitor about 750 BC, approaching the citadel from the outer town, would have passed up a cobbled road through a gate, guarded on either side by large stone animals, that barely hinted at the magnificence within. The road climbed to a level surface some fifteen metres above ground-level, a height of 120 brick-courses in Ashurnasirpal's terminology. It went on, passing on the left a temple dedicated to Nabu, the increasingly influential god of writing, and on the right the local government offices, before emerging into what seems to have been a central square or piazza. This area has been only partly excavated, but the walls on at least two sides were decorated with sculptures which

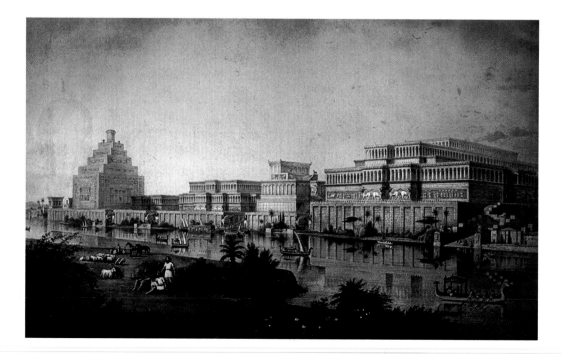

27 Reconstruction, published by Layard, of Nimrud. The Assyrian features of the architecture are swamped by columns and other anachronistic peculiarities mainly taken from the monuments of Persepolis and the Mediterranean world.

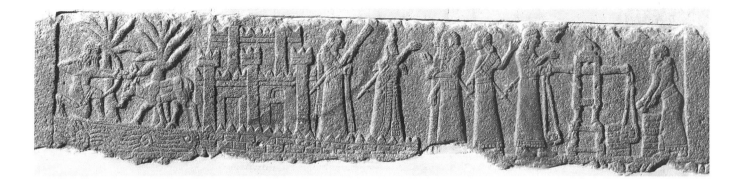

28 A panel from the Rassam obelisk: Ashurnasirpal watches tribute being weighed on a pair of scales. From Nimrud, about 865 BC.

might be called colossal except that there were far bigger and better examples of the kind in the royal palace itself. In front of a sculptured temple facade were at least three free-standing monuments: a figure of a courtier, over life-size, which is now in the Iraq Museum, and two obelisks. One was Ashurnasirpal's Rassam Obelisk, carved with people bringing various kinds of tribute, both raw and finished goods: copper ingots, timber, furniture, textiles, and so on. Lines of writing refer to other items, frequently including gold and silver, and one carved panel shows treasure being weighed on 28 a pair of scales. This obelisk was broken up in later antiquity, probably because it was made from a kind of basalt which can be turned into excellent querns and grinding stones for grain; Rassam recovered only about half the carved surface, but there was just enough to restore the shape. The other, the Black Obelisk of Shalmaneser, is complete, and has scenes of the same general nature. Another object found by Layard in this area of the Nimrud citadel was part of a Babylonian boundary stone, something that must have been brought back as booty from some Assyrian campaign. It looks as if this piazza was systematically decorated with commemorative monuments and trophies: we meet the same idea in the great gate of Ashur itself, where a virtual museum of sceptres captured from foreign rulers was displayed.

Our visitor still had some 200 metres to go before he reached the great outer courtyard of Ashurnasirpal's palace, still in official use over a century after its construction. Once there, he was confronted with a facade that was probably more imposing than anything ever built in Assyria before. In the middle, facing outwards, flanking the central door to the royal throneroom, there will have been one pair of colossal human-headed winged animals. These had disappeared before Layard dug at Nimrud, but two pairs of similar animals still partly survive on buttresses to either side of the central door. These are some of the ones with five legs. Their horned caps indicated divine or semi-divine status, and Assyrian writings speak of such monsters prowling to and fro, their eyes turned threateningly in all directions. While these colossi, and two more pairs in side entrances to the throneroom, were left behind by Layard and can still be seen at Nimrud, he did remove six others from elsewhere in the palace: four for the British Museum, and two unwanted duplicates for his private collection which has ended up in New York. The five pairs of colossi on the facade, with two more on internal doors, make up a total of seven guarding the throne-room, a figure that may have had magical significance.

Other semi-divine figures, genies, accompanied the facade colossi, but the principal subject of the carved slabs, away from the main central door and buttresses, was secular. On the left there was a group of foreigners bringing tribute towards a side-door through which the king's throne was sometimes visible; and on the right a longer procession of tribute-bearers led

up to a group of slabs on which were carved the king himself and high Assyrian officials. The dress of the foreigners shows that they too are from the west, bringing luxury goods and status-symbols: one of them has apes, animals that 29 may have come from Egypt or from the incense-producing lands of southern Arabia.

In a corner of the courtyard, to the left of the throneroom facade, was a small oblong stela which Layard missed; found by Mallowan, it is now in the Mosul Museum, and describes the festivities when the palace was completed about 860 BC. There are said to have been 69,574 guests at the feast, among them 16,000 local residents, and we have details of the menu. This stela had a carving of the king, with divine symbols, and the corner was probably a small shrine where visitors paid their respects, through the king, to the gods of Assyria.

Through the central door of the facade there was visible, on the opposite wall, a slab carved with a scene that appears repeatedly in Assyrian art, often as embroidery on the royal robes; there was another example at the left-hand end 30 of the throneroom, behind the throne itself. In this scene the Assyrian king is shown twice, on either side of a very stylized tree. The two kings seem differently dressed at first sight, but this is because the outer robe was not symmetrical, and the right and left profile views were in reality far from identical, as with a modern sari. This is the king in his role as high priest and he is lifting his hand in worship towards a winged disc. While the disc certainly represents the sun in some circumstances, there is a question-mark over its precise meaning when, as here, there is a god riding in it. This god in the disc sometimes accompanies the army in battle; there is also a version in which two extra gods appear riding on the wings. It is a natural supposition that the god in the disc is here not the sun god (an important but not the most

30 The king on either side of a Sacred Tree, with a winged disc above and protective genies behind. There were two versions of this scene in Ashurnasirpal's throneroom: this one, from behind the throne, and a second one opposite the central door. From Nimrud, about 865 BC.

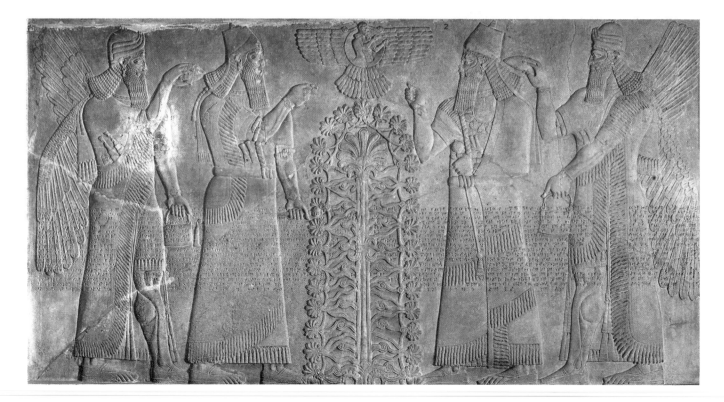

26

important member of the Assyrian pantheon), but rather the supreme national god, Ashur. Religious iconography in Assyria was flexible, and we may suspect that different gods were increasingly liable to be regarded less as individuals and more as alternative aspects of generalized divinity. Universal supremacy of the god Ashur was the corollary of Assyrian political dominion, and he was not averse to appropriating attributes from his rivals. This winged disc, with resident god, is one Assyrian symbol which was eventually to reappear in the imperial art of Persia.

The stylized tree between the kings, below the winged disc, is usually called a Sacred Tree or even, misleadingly, a Tree of Life. It bears some distant relationship to the palm-tree, having a palmette on top of the trunk and a trellis of smaller palmettes around it; but other examples are adorned with buds and pome-

granates too. This is the distinctively Assyrian form of a symbol, the palmette, which had long been known in Mesopotamia and the Levant. Its exact meaning escapes us, but it could be taken as representing in some way the fertility of the earth, more especially the land of Ashur. Sacred Trees were a regular feature in the decoration of Ashurnasirpal's palace. They often occupied corner slabs, with the trunk of the tree in the very corner; this was a convenient way of filling an awkward space, and providing a symmetrical thematic link between two walls at right-angles. The Sacred Tree is commonest, however, in between the protective winged genies which occupied the walls of several of the principal rooms. It seems that, though no two trees were exactly alike, the arrangement of the branches on the two sides of each single tree was always identical.

There are two of the protective genies on the throneroom centre-piece, one behind each king. They are minor gods, *apkalle*, typically Assyrian in form. These have the horned cap of divinity, though others may have a diadem alone. On top of their kilts they wear tasselled robes of a kind often worn by the king but not by humans of lower rank. This pair of genies have two wings each, like the majority of their fellows, though some have four. A few genies are exceptional in having no wings at all, and this has led to the theory that they are not divine beings but priests dressed up as such; in practice, however, the absence of wings can always be accounted for by exigencies such as lack of space on the slab, and there is no reason to think that the scenes in which the genies participate were ever enacted in the flesh. On the contrary, we have Assyrian texts which refer to genies of this nature, describing some of them, which have eagle's heads or fish-cloaks, in unmistakable terms. While the texts actually concern clay figurines, which were buried beneath the floors of buildings, rather than figures sculptured on the walls, they make it clear that the function of such beings, like that of the colossi, was protective: they were there to keep bad luck away.

Naturally they needed the appropriate magical equipment to carry out their duties. Many of

29 *left*. A tributary from the west, with a pair of apes. From Nimrud, about 865 BC.

31 *right*. An eagle-headed protective genie, from the entrance to the shrine of Ninurta, Nimrud, about 865 BC. Compare fig. 3.

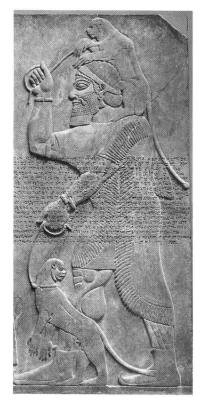

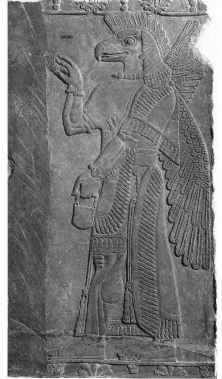

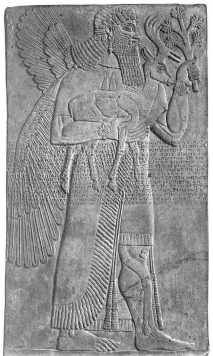

32 A protective genie carrying a deer. This figure originally guarded one of the side-doors of Ashurnasirpal's throneroom. From Nimrud, about 865 BC.

33 Lion leaping at Ashurnasirpal's chariot. From Nimrud, about 865 BC.

them, like the pair behind the centre-piece kings, accordingly hold a cone in the raised right hand and a bucket in the left. As the cone slightly resembles the male flower used in the fertilization of date-palms, and the genies often stand in front of the Sacred Tree, it has been suggested that they are engaged in the act of fertilization, and the date-spathe may indeed have been a remote ancestor of the genies' cone. Yet what the genies hold resembles a pine-cone just as closely, and it is applied, in the sculptures, not just to trees but also to people or places that might need magical protection: to doorways, or in this instance to the king. We cannot really envisage how these magical processes were thought to have worked; what really mattered to the Assyrians was that the genies should be correctly shown in the manner sanctified by arcane tradition. Other genies have the bucket without the cone, or different objects such as maces, flowers, or animals. There was a particularly impressive 32 range of genies on the walls of Ashurnasirpal's throneroom, which needed thorough protection against the perils of the outside world.

Other slabs from the throneroom provide our earliest examples of the type of architectural decoration that was most typical of the state apartments of the Assyrian palaces. They are carved with narrative scenes. Those in the British Museum mostly derive from the long southern wall of the room, opposite the facade doors. The slabs are nearly all complete but for an inscription which was written across the middle of each of them, separating the narrative into two registers; Layard noticed that this inscription was always the same, and therefore cut it away to save weight. It was in fact repeated on virtually every slab in the palace, and the scribes varied greatly in the skill with which they accommodated it among the carved details of genies' robes. It recorded Ashurnasirpal's qualities as a king, the number of foreign lands he had conquered and the animals he had hunted; these are aspects of his reign with which the narrative sculptures deal too.

The first two slabs, closest to the throne and

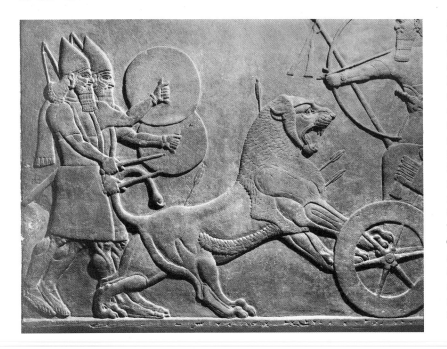

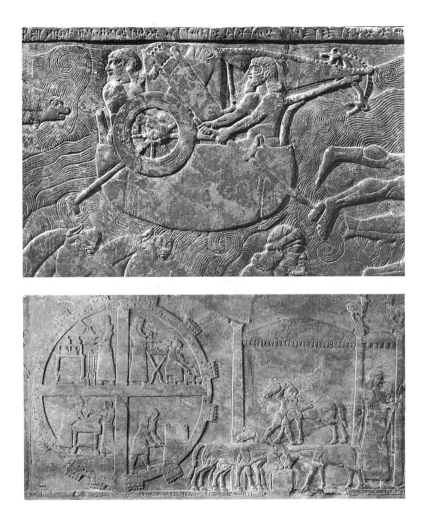

34 Assyrian soldiers ferrying a chariot across a river on a coracle. From Nimrud, about 865 BC.

36 Ashurnasirpal's camp, with scenes of cooking, and horses being groomed in front of the royal pavilion. From Nimrud, about 865 BC.

division, the subjects of the carvings are treated as entirely independent compositions. Traditionally, scenes of this nature were brief, almost symbolic representations, where the critical moment at which the king killed his prey was all that was necessary. Assyrian sculptors transferred this kind of composition, which is exemplified in the White Obelisk, to their new medium, the wall-slab, but did not immediately exploit the full potential of wall space for the creation of compositions on a far larger scale.

Similarly the upper registers of the next two slabs show two incidents from attacks on enemy cities, and the pair are clumsily juxtaposed. Below, in contrast, there is a single composition running across two slabs: the king and his courtiers receive a procession of prisoners: an Assyrian soldier who has distinguished himself in the war kneels at the king's feet, and items of booty, cauldrons and ivory, are shown schematically in mid-air. This group of scenes may all be concerned with Ashurnasirpal's expeditions along the Euphrates.

Further along the wall, a run of nine slabs are carved with narrative scenes which, in each register, are divisible into about three compositions. Precisely where the divisions lie is arguable, and maybe we should not try to impose too precise an interpretation on what may have been intended more as a general expression of Ashurnasirpal's invincibility. What is evident, by comparison with later Assyrian sculptures, is that these are experimental, less logical than what was to come, yet correspondingly more unpredictable and vigorous.

First, in the top register, there is a battle, with chariots and horses; then victory celebrations at the Assyrian camp; then a siege. The lower 34 register has first the crossing of a river, probably the Euphrates; then prisoners brought before the king; and then another siege. All the scenes 35 are crowded with details, some of symbolic value, others anecdotal. For instance, the Assyrian camp is divided schematically into 36 four quadrants showing various stages in the preparation of food and, once, extispicy — the study of the entrails of sacrificed animals with a view to ascertaining the likely course of future

probably calculated to give the king greatest pleasure, showed his achievements in the hunt. Above he is killing lions and wild cattle, below 33 he is celebrating over the dead bodies. As his annals recount, 'the gods Ninurta and Nergal, who love my priesthood, gave me the wild animals of the plains, commanding me to hunt. 30 elephants I trapped and killed; 257 great wild oxen I brought down with my weapons, attacking from my chariot; 370 great lions I killed with hunting-spears.' It is noticeable that, though the slabs with these scenes fit flush together, and there is no significant vertical

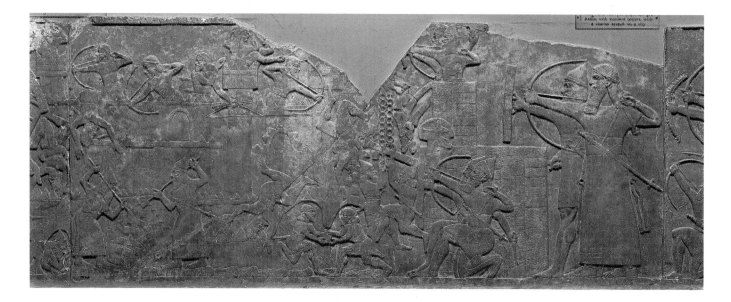

35 An Assyrian siege-engine under attack. The enemy have lowered a chain from above, to catch the great projecting beam that is battering their town-wall, but Assyrian soldiers are holding it down in position with hooks. Blazing torches are also being thrown, to set the machine alight, but two jets of water, poured from inside the cab, dampen its surface and control the flames. Meanwhile other Assyrians are tunnelling through the wall. From Nimrud, about 865 BC.

events. The structure to the right of the camp is the royal tent or pavilion, its poles decorated on top with figures of wild goats, an animal that may have been sacred to Ashur; in front a horse is being groomed, while others drink from a 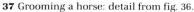 large bucket.

The opposite wall of Ashurnasirpal's throne-room probably showed his attack on Hittite territory west of the Euphrates, and there were further narrative sculptures, poorly preserved, in another reception area of the palace. The private royal apartments, in contrast, were decorated with more formal scenes, mainly large-scale groups of the king with courtiers and magical figures. Few visitors can have penetrated that far, but there do exist Assyrian sculptures which tell us something about the inner workings of the court.

37 Grooming a horse: detail from fig. 36.

The Assyrian Court

While in some of the narrative compositions from Ashurnasirpal's throneroom the figure of the king alone stands for his entire army, most include representations of other senior officials. They play their part in the fighting, and attend on the king in triumph. Their distinctive dress, when not in action, is a long robe partly covered by a woollen shawl which is wound over the left shoulder and around the waist.

Some of them wear beards and can be identified as members of the royal family or the Assyrian nobility. There is one, in particular, who normally stands directly in front of the king and wears a diadem of the royal type. There is never more than one such figure in a composition, and he is probably the crown prince or heir apparent. Assyrian practice seems to have been that the throne passed not necessarily to the previous king's eldest son but to whichever member of the royal family was thought most suitable; this resulted in a series of civil wars. At times, however, there was certainly one individual who was officially recognized as heir apparent, and his natural position in sculpture would have been at the head of the line of courtiers before the king. Thus a slab from Khorsabad shows the king Sargon facing another man who is presumably his heir Sennacherib. 38

Other courtiers are beardless, and should probably be identified as eunuchs. There were many such people at the Assyrian court, performing many functions besides guarding the harem, and it seems that most beardless Assyrians in the sculptures, apart from those who are obviously women and children, belong in this category. There is one clear exception, the priesthood: 39 some priests were shaven as a mark of office, but they are easily distinguished because they are not only beardless but hairless too, and wear tall hats. One of the most powerful eunuchs was the official who controlled access to the king's presence; he may be identified with the figure, regularly seen standing last in the line of courtiers before the king, who waves 40 one arm towards approaching processions of tribute-bearers or prisoners.

Ashurnasirpal on campaign was accompanied by his bodyguard, and by his eunuchs; in peacetime he is represented as drinking, with eunuchs attending to his needs. Close contact 41 with the king brought influence and power. Individuals bearing titles such as 'chief cup-bearer' appear in the Assyrian records holding high administrative positions, and it seems that eunuchs came to dominate the civil service. As the empire expanded under Ashurnasirpal and Shalmaneser, they were appointed as governors of major provinces, and some of them held office continuously for as much as thirty years. This development, offensive to the traditional nobility, seems to have been one cause of a rebellion which broke out towards the end of Shalmaneser's reign. The rebellion was only finally suppressed under the next king, Shamshi-Adad v (823–811 BC), who stressed the legitimacy of his claim to the throne in the iconography of his royal stela: he appears wearing his beard in 42 a strange archaic style, and the cuneiform text is written in an artificially antique script.

A consequence of Shamshi-Adad's victory was that sculptured monuments, for almost a century, were liable to be commissioned by

38 Sargon II, left, facing a high official who is probably the crown-prince, Sennacherib. From Khorsabad, about 710 BC.

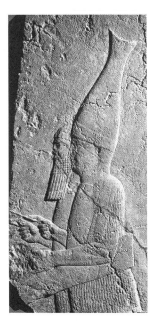

39 Assyrian priest playing a musical instrument. From Nineveh, reign of Sennacherib (704–681 BC).

40 *right above*. Eunuch introducing Arab prisoners into the royal presence. From the palace of Tiglath-pileser III, Nimrud, about 730 BC.

42 *right below*. Stela of Shamshi-Adad V (823–811 BC), from Nimrud.

senior officials, probably eunuchs, rather than by the king. A prominent example was the statue of a beardless courtier in the main piazza at Nimrud. Most of these monuments are elsewhere, but the British Museum has two free-standing statues of guardian deities from the 43 Nabu Temple at Nimrud. These were erected by the local governor, on his own behalf and on behalf of the king Adadnirari III (810–783 BC) and of the queen mother Sammuramat, clearly a forceful character whose name was remembered into the Greek period, when she surfaces as the legendary queen, Semiramis. This is a rare indication of the undoubted power of women at the Assyrian court; they were seldom represented in sculpture, the main exception being the queen who appears with her maids in a picnic scene from the private apartments of the last great Assyrian king, Ashurbanipal (668–627 BC).

The tradition of the annual campaign lapsed after the civil war of the 820s, and the borders of the Assyrian empire remained for a long time relatively static. It was a phase of imperial consolidation. The local governors seem to have concentrated on ensuring the prosperity of the regions under their control. Resources were no longer diverted to the creation of magnificent new palaces for kings who, after all, had few achievements to commemorate. By about 750 BC however, the absence of strong central control was damaging the security of the state, and the neighbouring kingdom of Urartu, in the north, was extending its influence into regions that had previously acknowledged Assyrian hegemony. There was then another revolution in Assyria, which resulted in the accession of a vigorous king, Tiglath-pileser III (745–727 BC) 44 who revived the aggressive policies of Shalmaneser: a rapid series of campaigns pushed the Assyrian frontier forward in all directions, and Urartu was repulsed.

Appropriately, towards the end of his reign, Tiglath-pileser started building a new sculptured palace. It was to be decorated, at least in part, with narrative sculptures. The scenes were arranged in two registers, as in Ashurnasirpal's throneroom, which probably provided the model;

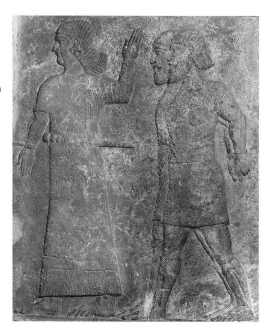

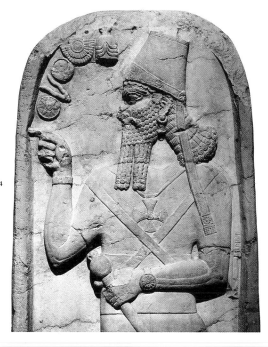

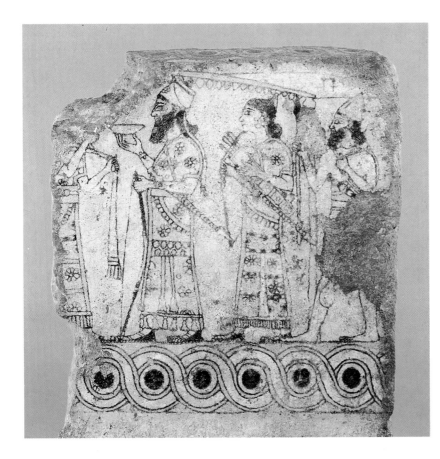

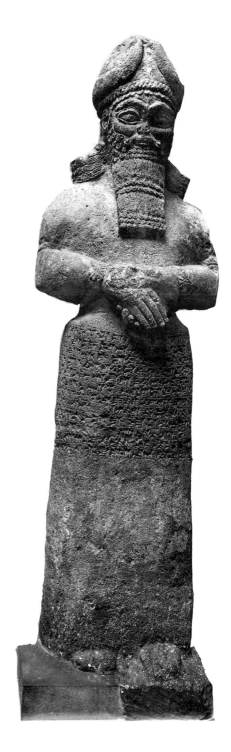

41 *above*. Assyrian king drinking, with attendants. A glazed tile from Nimrud, probably reign of Ashurnasirpal II (883–859 BC).

43 *right*. Guardian deity from the Nabu Temple, Nimrud, erected under Adadnirari III (810–783 BC).

the central band of inscription, however, occupied a smaller proportion of each slab, and slabs were no longer treated as separable units. This palace was left unfinished on Tiglath-pileser's death, and his son, Shalmaneser V (726–722 BC), was deposed soon afterwards by another king, Sargon II, whose very name, 'True King', betrays the suspect nature of his claim to the throne. Sargon moved the Assyrian capital to his own foundation of Khorsabad, built in imitation of Nimrud, and the older city was neglected. Tiglath-pileser's palace remained in its unfinished state, and its sculptured decoration was eventually dismantled by Esarhaddon for incorporation in a new building of his own. As a result these sculptures were discovered in a

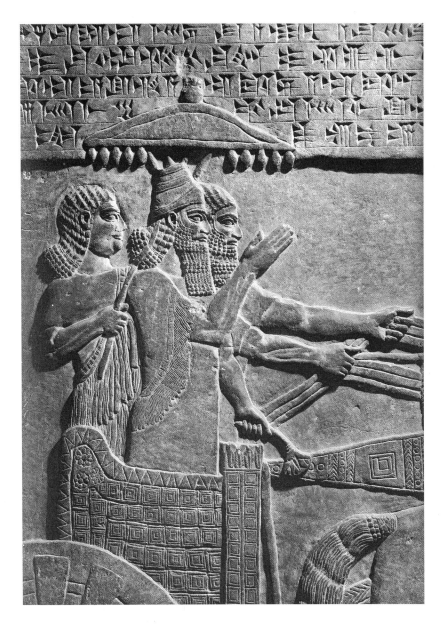

44 Tiglath-pileser III in triumph. From Nimrud, about 730 BC.

very fragmentary state, and only a few of them have reached London.

One slab includes an intriguing detail which helps account for the innumerable circumstantial details which appear in Assyrian narrative sculptures. Two men, both eunuchs, are taking records of spoil from a captured city in Chaldaea. One holds a rectangular object which was presumably a clay tablet on which cuneiform was written; the other holds a scroll. It used to be thought that the latter was a scribe writing in the Aramaic language, but an Iraqi scholar has offered a far more convincing explanation. He suggested that the man with the scroll was a war-artist, illustrating the events about which his colleague is writing. We know that drawings were made on scrolls in this period, and there are countless details in the Assyrian sculptures which have to be derived from the work of artists who drew them in the field. Here then we have the earliest representation of one of these artists at work. There is no parallel in the narrative sculptures of Ashurnasirpal and Shalmaneser, and we cannot be sure that such men were employed regularly at that time. After the reign of Tiglath-pileser, however, they appear frequently, sometimes with scrolls, sometimes with hinged boards, the ancient equivalent of bound books. The records that they kept were available as notes to the palace sculptors. These war-artists probably belonged to the relatively small group of Assyrians who could read and write. Even the kings were usually illiterate, if we may judge by the way in which Ashurbanipal boasts of having learned to read himself, and the scribal art was probably regarded by most of them as demanding far too much undignified concentration.

Since Khorsabad was discovered by the French, the finest Sargon sculptures are not in London. One slab found there by Layard is, exceptionally, in black stone, and shows the hunting of small game. A superb pair of human-headed winged bulls were originally placed at one of the gates of the citadel; their attendant genies are shown facing outwards rather than, as commonly, in profile. The palace walls excavated by Botta were largely adorned with processions of tribute-

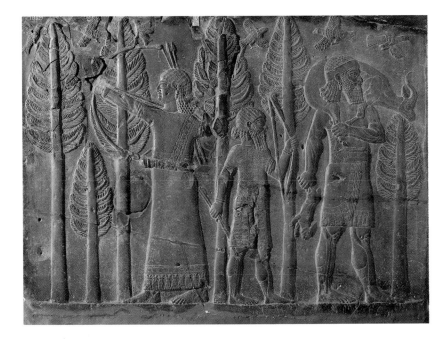

bearers and eunuch courtiers, but there were also narrative scenes of much the same nature as Tiglath-pileser's. Two remarkable innovations, however, occur in some slabs, now in Paris, which show the transport of timber by sea. Instead of being split into two registers, these scenes occupy entire slabs, from top to bottom. Moreover two traditional patterns, curls representing water and scales representing hills or mountainous terrain, are used by the sculptor as an over-all backing which enables him to place items like men or boats one above the other, within the composition, without giving the impression that they are unnaturally suspended in mid-air. The potential of these new techniques was to be fully recognized by the sculptors working for Sargon's son, Sennacherib, a few years later.

46 Hunting scene, carved in dark stone, from the palace of Sargon, Khorsabad, about 710 BC.

45 Two Assyrian officials taking records: one is a scribe with a clay tablet, the other probably a war-artist with a scroll. From Nimrud, about 730 BC.

47 Fallen rock-sculptures, showing colossal winged bulls, at the head of one of the canals by which Sennacherib brought water to Nineveh. Khinnis, about 690 BC.

48 A park, probably at Nineveh, with a royal stela and columned summer-house; water for the trees arrives from the right, across an aqueduct with pointed arches. This slab, carved in the palace of Ashurbanipal about 645 BC, apparently shows a landscape created by his grandfather Sennacherib.

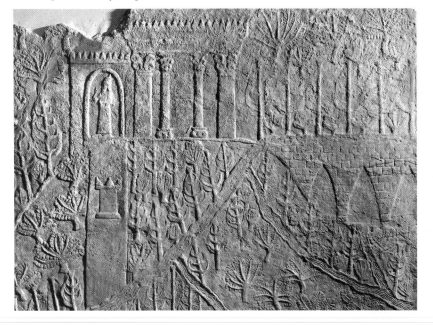

The Palace of Sennacherib

Sennacherib stands out, among Assyrian kings, as a man of exceptional enterprise and open-mindedness. One of his aims, apparently, was to create a stable imperial structure at peace with the outside world, but he knew that stability could only be ensured by asserting Assyrian power whenever it was challenged. In his palace at Nineveh, which was built over about ten years around 700 BC, scenes of military triumph accordingly play a dominant role. The palace itself was grander and more imposing than anything his forefathers had built; Sennacherib named it the Incomparable Palace, and it was the glory of his new capital city. Nineveh, unlike Khorsabad, was sensibly sited as a capital; it had long been a major city. Sennacherib planned to transform it into a place whose size and splendour would astonish the civilized world. The palace architecture was fully matched, in scale and ingenuity, by a system of canals and stone aqueducts which 47-9 brought water forty or fifty miles, from the Zagros mountains, to the parks, orchards, and allotments of Nineveh.

One palace courtyard was decorated along two sides with a series of sculptures that show, instead of warfare, the transport of a winged bull from quarry to palace. The operations are 14 watched by the king in person, who stands in a 50-2 small carriage pulled not by horses but by men; the shaft-pole ends in a handsome finial showing a horse's head. Most of Sennacherib's attendant officials, in this and other scenes, are bearded men; there are relatively few eunuchs in his entourage. Beardless figures do appear, however, in great numbers, serving a far more menial purpose. They are engaged in light labour, carrying poles or coils of rope and pulling carts loaded with equipment for moving the bull. We know that Sennacherib made significant political changes at the start of his

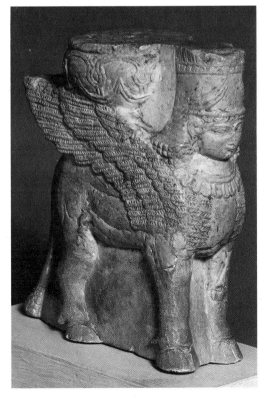

49 *above*. Remains of one of Sennacherib's aqueducts, which was supported on corbelled stone arches as it crossed a water-course at Jerwan, between Khinnis and Nineveh. Compare fig. 48.

54 *far right*. Marsh near Nineveh, with deer and wild pig. From Sennacherib's palace, about 700 BC.

55 *right*. Miniature column-base in the form of a female sphinx: the legs, which are restored, should probably be those of a lion rather than a bull. From Nineveh, 7th century BC.

reign, and it is possible that one thing he did was purge and humiliate the eunuchs who must still have formed a powerful and sometimes dangerous party at the imperial court. Here, at any rate, they seem to be doing something very different from their normal tasks of running the palace and administering the empire. The usefulness of this class of people has been proved time and time again, however, and by the reign of Ashurbanipal, Sennacherib's grandson, there seem to have been more of them than ever.

As the bull is hauled on its way to Nineveh, the hilly background gives way first to a swamp, then to a river, clearly the Tigris. In the swamp there are wild pigs and deer, and this 53-4 may be the very one Sennacherib created at Nineveh. 'I had a swamp made to control the flow of water, planted reeds there, and released herons, wild pigs, and other animals. . . . The plantations were most successful: the herons which came

53 *left*. Assyrian orchards near Sennacherib's quarry, with vines, figs, pomegranates, and pines. About 700 BC. Compare fig. 14.

50 *below*. A human-headed winged bull, which has been roughed out in the quarry (compare fig. 14), is being dragged across country on a sledge. While four gangs of prisoners pull at the front, another group insert a huge lever under the curved back of the sledge, secure the lever with a wedge, and then swing on the lever in order to raise the back. Evidently the sledge moved forward in a series of jerks. Rollers were placed underneath, and the whole operation was directed by men who stood, with trumpets, on the sledge itself. From the palace of Sennacherib, Nineveh, about 700 BC.

51 *above right*. Another stage in the movement of a winged bull for Sennacherib's palace at Nineveh, about 700 BC.

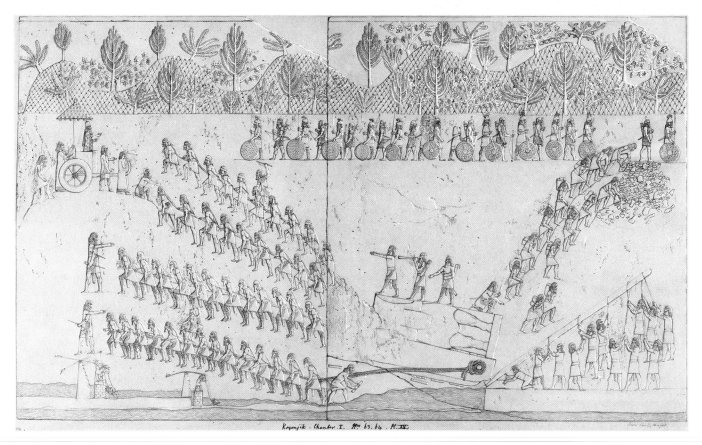

Koyunjik. Chamber I. N⁰ 63. 64. Pl. XV.

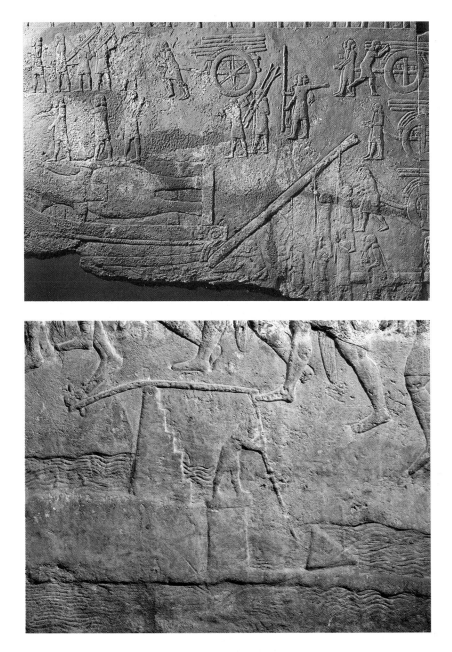

52 Diverting a water-course so that a winged bull can pass without being bogged down. Men are raising water from one level to another by means of triangular buckets attached to long beams; the beams are weighted at the other end, and carefully balanced on central built-up stands, so that the buckets will rise easily. This kind of water-sweep is still used in parts of the Middle East.

from far away nested, and the pigs and others produced young in great numbers.' Here Sennacherib was following in the steps of earlier kings, several of whom collected exotic beasts, but wild pig are or were common in parts of northern Iraq, and it seems that this swamp was something approaching a real nature reserve, certainly not a mere collection of caged animals from abroad.

Although Sennacherib followed his predecessors' example in placing massive human-headed bulls at many of the doorways of his palace, he also introduced a new range of protective genies, types that were at home in areas, outside the Assyrian homeland, that had now been incorporated into the empire; it seems that the traditional Assyrian winged genie was losing his influence in the increasingly cosmopolitan imperial culture, and by the time of Ashurbanipal even the colossal bulls had become old-fashioned oddities, unsuitable for a royal palace.

One architectural feature, which had appeared sporadically in Assyria before Sennacherib but which he used with much greater frequency, was the column. This was introduced from the provinces to the west. A few stone column-bases, which supported wooden shafts, have been discovered at Nineveh and elsewhere. It appears that Sennacherib's palace sometimes had columned porticoes in front of its facades; one of them is described in an official record. There were columns of bronze, or of cedar overlaid with metal, standing on cast bronze bases in the shape of lions; attention was drawn to the fact that the method of manufacture was much superior to that used previously, that is to say, by Sennacherib's father. Naturally these porticoes did not survive the sack of Nineveh; the wood was burnt, the metal taken away. Yet it so happens that one of Ashurbanipal's sculptures shows part of a city which is almost certainly Nineveh, with one of Sennacherib's porticoes visible above the ramparts. There are striding lions, "open at the knee" as Sennacherib insists, supporting cushion-shaped bases on which the columns stand. Behind them are colossal human-headed winged bulls.

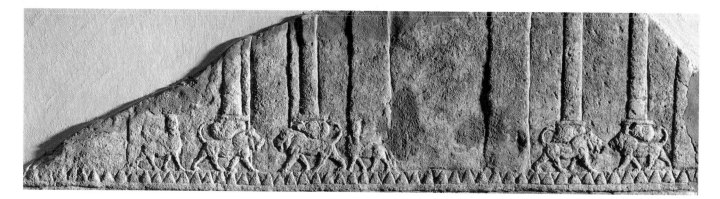

56 *above*. This sculpture, from a series in Ashurbanipal's palace, about 645 BC, probably shows one facade of Sennacherib's palace at Nineveh, completed about half a century earlier.

57 *right*. A Phoenician ship. From Sennacherib's palace, Nineveh, about 700 BC.

58 *far right above*. A recarved slab from Sennacherib's palace, Nineveh. The reeds on the left are original, about 700 BC, but the soldiers were added about 630–620 BC.

59 *far right below*. Chaldaeans hiding from the Assyrians in a clump of reeds. From Sennacherib's palace, Nineveh. About 630–620 BC.

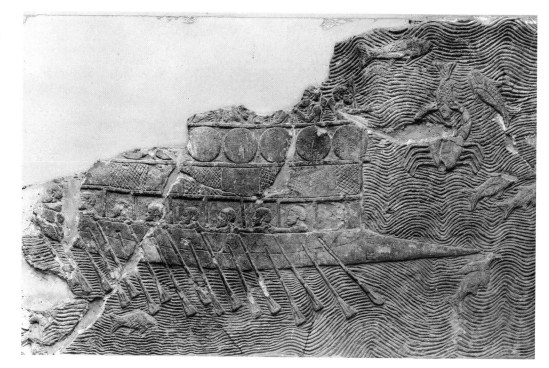

Most of the rooms in Sennacherib's palace were probably decorated with scenes of warfare. Many small fragments survive, including one that shows a Phoenician ship, and a series 57 dealing with the capture of a city whose name, ending -*alammu*, was once thought to represent Jerusalem; the finest extant composition from Sennacherib's reign is one showing the capture of Lachish, discussed below. One reason why 65-73 we know less about Sennacherib's sculptures than Layard's reference to almost two miles of bas-relief in this palace might have led us to hope, is that many of them are much later in date. Despite the care with which he built his palace, Sennacherib was well aware that it might not long outlast his reign. 'In days to

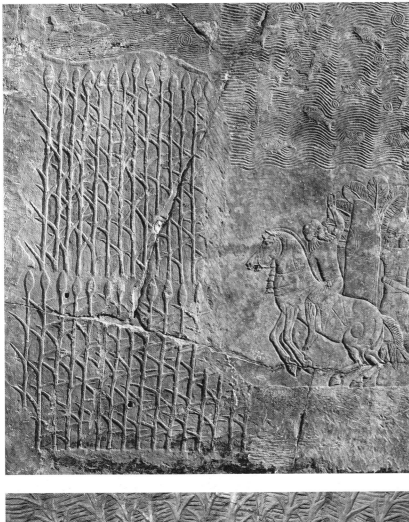

come, when these walls become old and begin to decay, let the ruins be restored by whichever of my descendants has been chosen by Ashur as shepherd of the land and people. Let him find the inscriptions which record my name, anoint them with oil, offer a sacrifice, and restore each of them to its place.' What did eventually happen, however, is that a later more frugal king, who did restore the palace, sometimes obliterated the old carvings in order to replace them with his own. There is a neat example of only partial recarving in one slab which has, on 58 the left, reeds and water which survive from the original Sennacherib scene; on the right they have been replaced by a skirmish in a palm-grove, with an Assyrian chasing a Babylonian or Chaldaean horseman. Above the fight there is a river with fish, just as in the original, and the two styles of carving, juxtaposed, are obviously slightly different from one another. Some of the Sennacherib reeds have been only partly chiselled away. The old carving was presumably left because its subject fitted admirably into the new composition, and probably also because it was situated in a dark corner.

One of these late series of sculptures, from a corridor in the palace, has a composition which begins, at the far left, with a battle in Chaldaea. The enemy have fled from the Assyrians into the reed-swamps where they are at home. Some Assyrians are boarding their boats while others search through the marshes. A few old men and women are crouching out of sight on one of the boats built from bundles of reeds; 59 others are slipping away along a backwater, while younger men shoot arrows from hiding-places. Some of the prisoners have their heads cut off, others are ferried back, right, to be escorted on firmer ground into captivity. They join the rear of a long procession of deportees. The composition is then broken, but is effectively continued in sculptures that were originally mounted on the opposite wall of the same corridor.

Here the Assyrians are bringing prisoners and animals through palm-groves towards the king. As usual there are the incidental touches, such as a mother stooping to give her child a

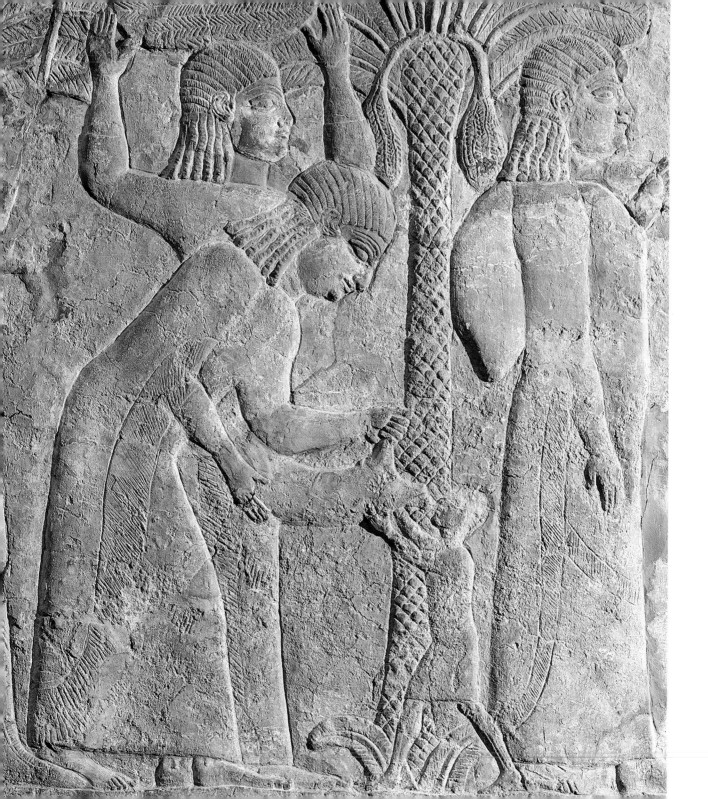

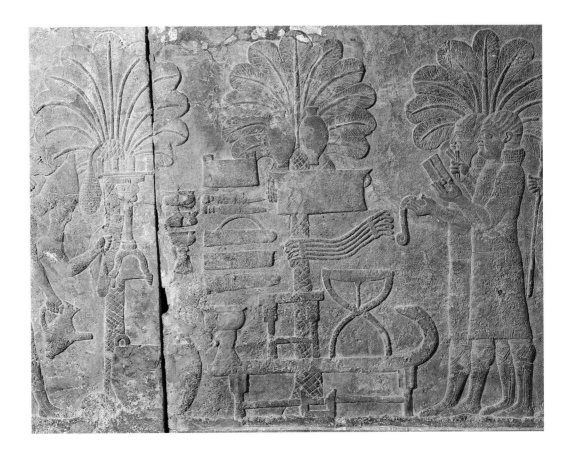

60 *left*. Captured Chaldaeans. From Sennacherib's palace, Nineveh. About 630–620 BC.

61 *right*. Assyrians, with hinged writing board and scroll, recording the loot from a Chaldaean settlement. From Sennacherib's palace, Nineveh. About 630–620 BC.

drink from a leather bottle, which inject human interest into what could have been a cold symbolic representation of the triumph of right over wrong. We cannot judge the motives of the sculptor, but he exhibits the detached realism of the good war correspondent. Careful records are being kept of captured goods which the soldiers are piling up: a bed and other furniture; a bundle of bows; metal cauldrons; quivers and swords; and a stand with a model of a fortress on top.

Another set of compositions, from the same late period, are arranged in two registers separated by a river. The effect is not dissimilar to that of much earlier sculptures, from Nimrud and Khorsabad, where the narrative registers were separated by the central band of cuneiform writing, and this is surely a deliberate reminiscence of the old convention. Above the river there is the storming of a city in Chaldaea, while underneath the Assyrian king watches as his men bring in heads, prisoners, and furniture. It seems likely, from various circumstantial details in this and other lost sculptures of the same series, that the king in question took an active part in the campaign. He is probably one of Ashurbanipal's sons, Ashuretelilani (630–623 BC) or Sinsharrishkun (623–612 BC), as their father preferred to stay at home. It is ironic that these, the last Assyrian sculptures to be made, show the conquest of people who would soon be rampaging, torch in hand and very far from conquered, through the cities of Assyria itself.

Biblical History in Assyrian Sculpture

One of the most exciting aspects of the Assyrian sculptures and written records, for Europeans living at the time of their discovery, was the light they threw on Biblical history. Assyrian kings were named in the books of Kings and Chronicles, and by some of the prophets, and here were their own independent monuments. The theory that the Bible was literally God's infallible word was widely held, but its proponents felt vulnerable before the advance of science; evolutionary ideas, soon to be expressed most forcibly by Darwin, were regarded by some as incompatible with the established Christian religion, and yet alarmingly plausible. So the archaeological discoveries of Botta and Layard, and consequent translations of Assyrian texts by scholars like Edward Hincks and Rawlinson, were seen as timely, almost divinely ordained. They proved that the Assyrians of the Bible were indeed historical personages; if the Bible was right about them, it might be right about everything else too.

Things have turned out otherwise. The Assyrian discoveries certainly confirmed that the early history of Palestine, as recorded in the Bible, was more than a work of fiction. On the other hand the Assyrian records, which are virtually contemporary with the events they describe and far older than the oldest available texts of the Bible, necessitate a critical approach to the Biblical evidence. The two sources can be used together to reconstruct what actually happened. The sculptures were intended to illustrate the Assyrian viewpoint, but are characteristically informative about the opponents too.

The first time, so far as we know, that the Assyrians became directly involved with one of the main Biblical kingdoms was in 853 BC. Shalmaneser III was then advancing through Syria towards Lebanon and Palestine. The local rulers formed an alliance to oppose him, and Ahab, king of Israel with his capital at Samaria, is said to have contributed 2000 chariots and 10,000 men. There was a battle, and the Assyrians claimed a massive victory; the subject was represented a few years later on one of the Balawat bronzes, but the enemy contingents cannot be distinguished from one another.

More significant than the Assyrian claims, however, is the fact that they kept clear of Syria for several years thereafter, and we may conclude the battle was more of a draw than a victory. The coalition of rulers opposed to Assyria was maintained for several years, but finally fell apart.

In 841 BC Shalmaneser's army reached the walls of Damascus, and then crossed westwards to the Mediterranean. The Assyrian annals state that, at this time, he received tribute from Ya-u-a, ruler of a kingdom that can be identified with certainty as Samaria. Hincks' recognition of Ya-u-a as the Biblical king Jehu received universal assent until recently, when a scholar suggested that the king in question might be Jehu's predecessor, Jehoram, but this alternative has not found favour. The incident, not mentioned in the Bible, is represented in four panels of the Black Obelisk, carved in 825 just 62-3 before Shalmaneser's death. Jehu's tribute was probably chosen as a subject because Samaria had been the southernmost kingdom to submit to Shalmaneser during his Syrian campaigns.

Jehu is likely to have viewed the Assyrian as a convenient ally against his neighbour, Damascus. Like Jehoash, another king of Samaria who sent presents to Assyria about 796 BC, he may not have appreciated the long-term threat. At this stage the relationship was mutually advantageous, and the official boundaries of the Assyrian empire were still a safe distance away beside the Euphrates. The situation changed with the accession of the Assyrian king Tiglath-pileser III, also known as Pul, who adopted a new policy towards the west and expanded the area under direct Assyrian rule. This brought him into conflict with an alliance of Syrian states led by a man long confused, owing to similarity of names, with the Biblical Azariah or Uzziah of Jerusalem. The Assyrians were victorious, and a long list of kings who sent tribute as a result, in 738 BC, includes Menahem of Samaria.

The kingdom of Jerusalem became involved a little later, when its king Ahaz appealed to the Assyrians for help against his neighbours. In three campaigns, 734–732 BC, Tiglath-pileser 64

62–3 Two panels from the Black Obelisk of Shalmaneser III, from Nimrud, about 825 BC. They form part of a single composition of four framed panels, one on each face of the obelisk, which show the Assyrian king receiving the tribute of Jehu, king of Israel.

Most of the figures in fig. 62 are Assyrians. Shalmaneser stands under a sunshade, with a cup in one hand and the other on the hilt of his sword; it is a relaxed pose, since Jehu was not a conquered enemy but had volunteered his tribute. Jehu himself, or perhaps his representative, is kneeling at Shalmaneser's feet; his distinctive dress marks him as a foreigner.

The tribute is brought in from the right, as in fig. 63, and some of it is described in the cuneiform caption over the procession: 'silver, gold, a golden vase, a golden dish, golden goblets, golden buckets, a load of tin, a staff for the hand of the king, wooden hunting spears.' This is a rough translation, since some of the words used are rare and we do not know their exact connotations, but the objects shown in the sculptures correspond reasonably well.

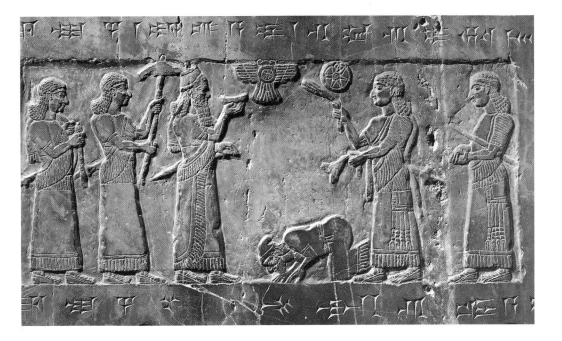

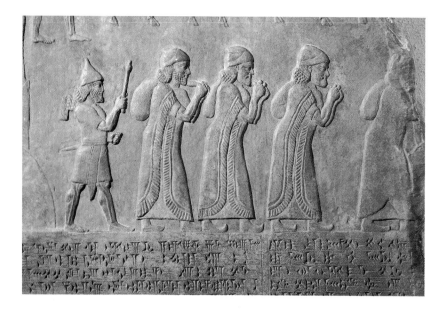

64 Prisoners captured at Astartu, a town south of Damascus. From the palace of Tiglath-pileser III, Nimrud, about 730 BC.

overwhelmed the area. Damascus and part of Israel became Assyrian provinces, and many of the inhabitants were deported. In 722 BC Israel, which had proved a troublesome vassal state, was finally eliminated and Samaria became capital of an Assyrian province. The Assyrian king at this time was Shalmaneser V, but he did not have time to commemorate his achievements in stone, and it was his successor, Sargon II, who claimed credit for the victory.

The change of ruler in Assyria encouraged the western provinces and vassal states, among them Jerusalem or Judah, to revolt. The suppression of the rebels, in 720 BC, was recorded by Sargon in one of the sculptured rooms of his palace at Khorsabad, but most of these scenes are only known from drawings. Sargon refrained from incorporating Jerusalem in his empire, probably because it would have been more trouble than it was worth, and the same policy was adopted by his son, Sennacherib, in similar circumstances in 701 BC. Sennacherib did, however, teach its people a painful lesson, and one episode from his campaign, the capture of Lachish, is illustrated in a series of sculptures now preserved at the British Museum. 65-73

Originally these sculptures formed the panel-

ling of a single room in Sennacherib's palace at Nineveh. It has sometimes been described as the royal throneroom; this is incorrect, at least in so far as Sennacherib had a throneroom of the traditional type elsewhere, but it was evidently a room of some importance, probably occupied by a high official. The carved decoration was far from exceptional, since many palace rooms showed comparable scenes of conquest in foreign lands. They had all suffered in the conflagration which destroyed the palace in 612 BC, and could only be removed from the walls in small pieces, one by one, which were themselves liable to disintegrate. Most of such sculptures were therefore left in position by Layard, and it was originally thought that the Lachish series could not be taken down safely. The existence of a caption, however, specifying that Lakisu was the town under attack, and the recognition of Lakisu as Biblical Lachish, stimulated the British Museum authorities to insist on their removal. In 1853, after elaborate key drawings had been made by the artist Charles Hodder, Rassam successfully dismantled the panelling. The tops of some slabs had been entirely destroyed by fire, but the series is about three-quarters complete. It is our finest example of military narrative art from Sennacherib's reign, apart of course from the slabs still in position at Nineveh.

Many of the sculptures in Sennacherib's palace showed compositions of the same basic type as the Lachish series, though with any number of variations in detail. There were whole rows of sieges and battles in the largest rooms, and some at first sight may appear chaotic. Always, however, when enough evidence survives, we find that there was a prevailing principle by which successive episodes were linked, culminating normally in the review of prisoners by the king. The compositions in their entirety were organized to fit their architectural setting, so that the prominent sections of wall, opposite doors and at the ends of long rooms, were carved with suitably imposing subjects such as the king in triumph or a large city under attack.

One small fragment, from another composition,

The Capture of Lachish
(figs. 65–73)

The sculptures recording Sennacherib's capture of Lachish in 701 BC were drawn by Layard during his excavations. The story moved from left to right round the walls of a room, with the city of Lachish itself on the panelling opposite the door, and Sennacherib enthroned at the centre of an end-wall. Sometimes Layard, pressed for time, economized: for instance the scale-pattern representing rough ground, which forms the over-all backing of the scenes, is clear on figs 65–6, becomes a schematic pattern of diamonds on figs. 68–9, and on fig. 70 is omitted altogether.

65 The first surviving scene: Sennacherib's artillery in action. Slingers are stationed at the rear. Next, closer in, come the archers – both Assyrians, who wear pointed helmets, and various auxiliaries. At the front, bottom right, are storm-troopers.

66 The attack is pressed home. Siege-engines lead the way, like tanks, as the Assyrians advance up artificial ramps that have been roughly surfaced with planks. Some of the soldiers work in pairs, one shooting arrows while his companion covers them both with a heavy shield. The Assyrians on the right are carrying away a throne, chariot, and other goods from the palace of the governor of Lachish.

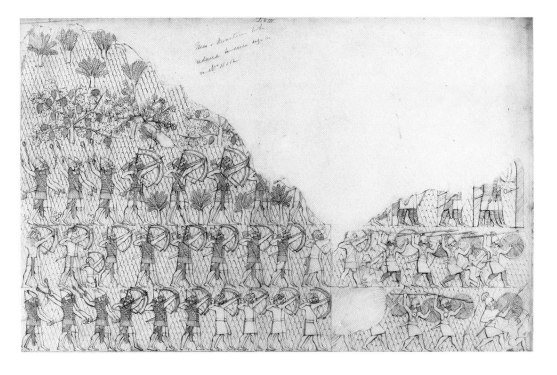

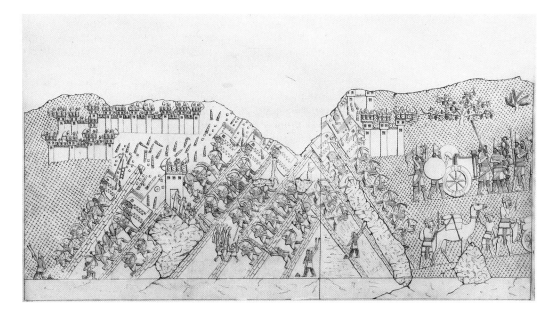

67 Reconstruction by a modern artist, Alan Sorrell, of the assault on the gate of Lachish as represented, on the left-hand side of fig. 66, according to the conventions of Assyrian sculpture. The assumption is that there was a single ramp at this point, with three siege-engines on it. Apparently the town-wall, further to the right, was attacked by means of another ramp, remains of which may actually have been found by archaeologists working at the site of Lachish. Sorrell has followed the Assyrian practice of telescoping action, anticipating the results of the assault, so that prisoners are already being marched out of the town-gate.

68 After the fall of Lachish, a procession of figures moves through a rocky landscape studded with vines, figs, and perhaps olives, the orchards of the town. Some of the prisoners are treated relatively well, and will probably have been resettled elsewhere in the empire: Sennacherib records, with or without exaggeration, that as a result of this campaign he deported 200,150 people. High officials, on the other hand, who were regarded as sharing responsibility for the rebellion against their Assyrian overlord, are being tortured and executed.

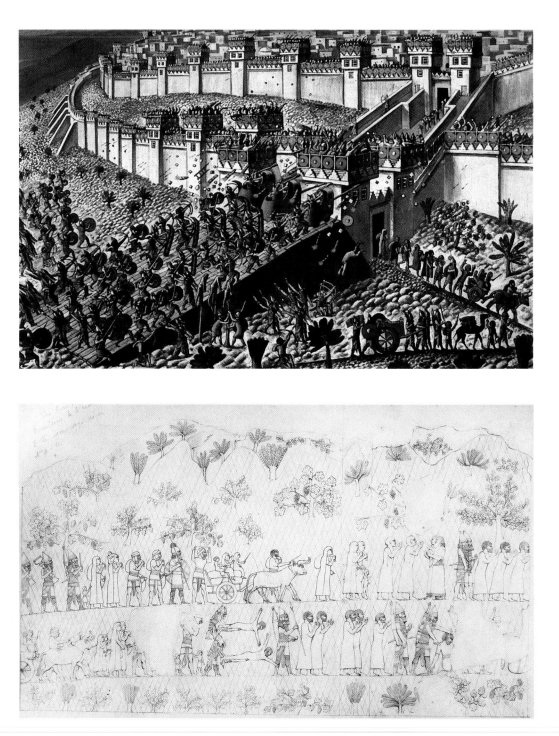

69 This scene is described in a cuneiform caption: 'Sennacherib, supreme king, king of Assyria, sat upon a throne while the booty of Lachish passed before him.' The king has stationed himself on a low hill; though Sennacherib was an enterprising general, the sculptures never show him, as they do show his predecessors, taking an active part in battle. His officers stand in front of him, followed by prisoners on their knees. The royal pavilion, behind the throne, consists of a screen attached to poles, with supporting guy-ropes, and there are two covered areas inside; the central part must have been open, since some sculptures show the heads of women or eunuchs peering out at this point. The royal party is accompanied by a squadron of cavalry, and below the pavilion is the king's chariot, led by grooms with magnificently tasseled quivers and followed by the bearer of Sennacherib's parasol.

70 This is the right-hand end of the Lachish composition, and shows the Assyrian camp. It has an oval wall, with proper defensive towers at intervals; other Assyrian camps, many examples of which appear on the Balawat bronzes, were sometimes round or rectangular. It seems to have been methodically planned, with a road through the middle. There are two pavilions, like the king's, and five open tents in which we see men making a bed, laying a table, grinding flour, cooking, and gossiping over a drink. One corner of the camp is occupied by a pair of chariots, with a standard mounted in each of them; these are the chariots of the gods, sometimes seen charging into battle. On this occasion two priests in tall hats are performing a ceremony before them; there is an incense-burner higher than the priests, and a sacrificial leg of meat on an altar.

The figures on the left form the rear of Sennacherib's entourage. The chariot is an oddity, clearly distinguished from others of this date by many details of the harness and the car: the wheels, for instance, have six spokes rather than eight. This is a ninth-century type of chariot, as used by Ashurnasirpal; we do not know why it accompanies Sennacherib here, though this is by no means the only example of deliberate archaism at the Assyrian court.

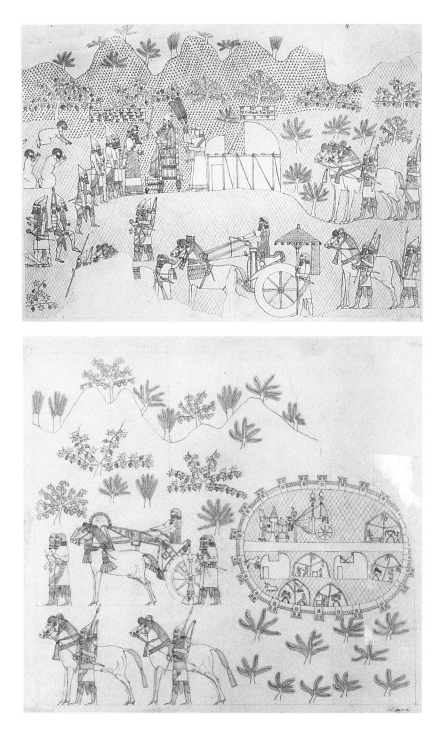

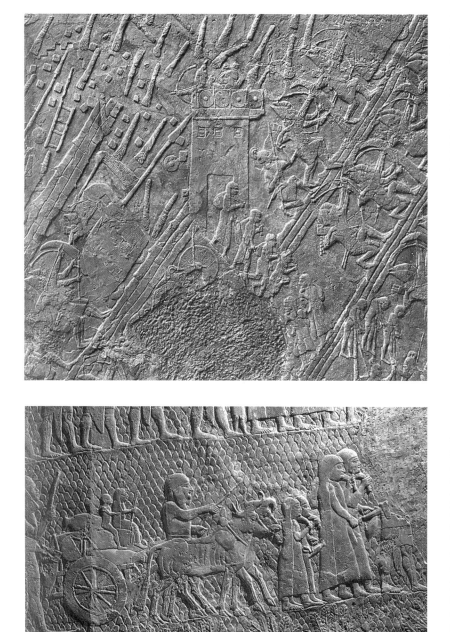

71 Detail from fig. 66: the assault on the gate-tower of Lachish. The Assyrian siege-engine has a protective leather covering, fastened with toggles, and a fireman inside ladles out water to prevent it being set alight. A giant spear, worked from inside the siege-engine, prods at the enemy fortifications, prising away square chunks of masonry. There is a platform projecting from the top of the battlements, with a ladder-like wooden framework holding a row of round shields. This structure too is tumbling down; elsewhere it brings a pair of chariots with it. Meanwhile the inhabitants of Lachish defend vigorously, with arrows, stones, and a hail of blazing torches.

72 Detail from figs. 66 and 68: a family from Lachish, taking their possessions with them into exile.

shows three prisoners being marched under escort through a mountainous landscape; each of them carries a lyre, and plucks the strings with a plectrum. The scene recalls the Biblical 74 psalm, written after a later group of Judaeans had been carried into captivity, in Assyrian style, by the Babylonian king Nebuchadnezzar: 'they that carried us away captive required of us a song.' The men's turbans mark them as coming from somewhere to the west of Assyria, probably Phoenicia or Palestine. Here the intense desire to extract, from the Assyrian sculptures, as many Biblical parallels as possible, has led to the supposition that these musicians too come from Judah, and it is true that among the booty which the Assyrians took back with them was Hezekiah's state orchestra. The dress of the trio, however, differs in several respects from that of the men of Lachish.

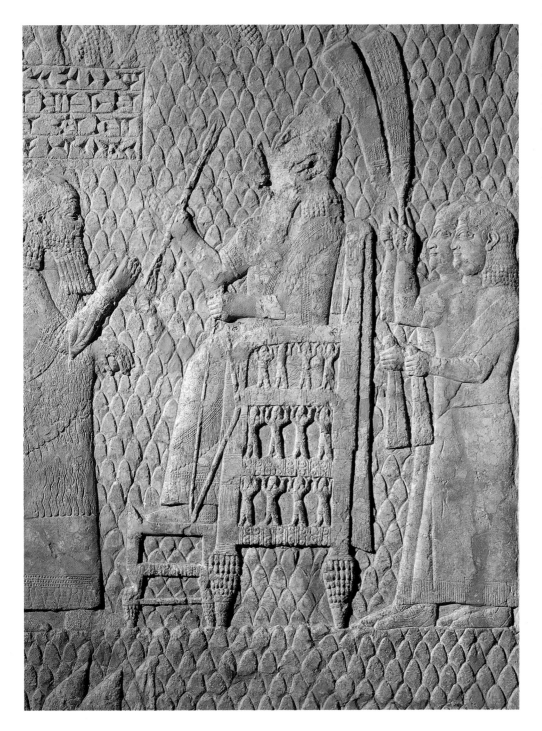

73 Detail from fig. 69: Sennacherib inspecting the booty from Lachish. He sits placidly, grasping his bow in his left hand and holding up some arrows in the right, a classic gesture of Assyrian kings in triumph. His throne is elaborately decorated with figures of protective genies, their arms raised as if supporting a heavy weight; there is also a handsome footstool. The crown-prince stands in front of Sennacherib, and behind are attendants, with napkins and fly-whisks. The scene is now marred by a wide gash across the king's face, made perhaps by an enemy soldier ransacking the palace in 612 BC. There are a number of Assyrian sculptures in which the figure of the king has been singled out like this for mutilation.

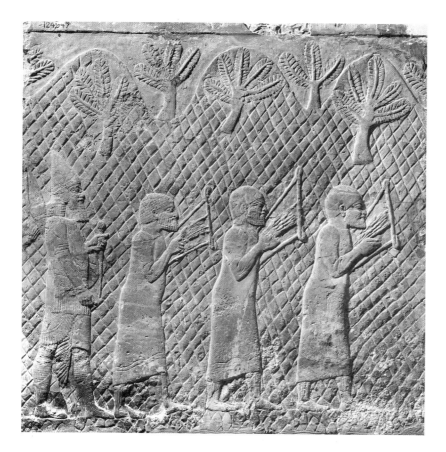

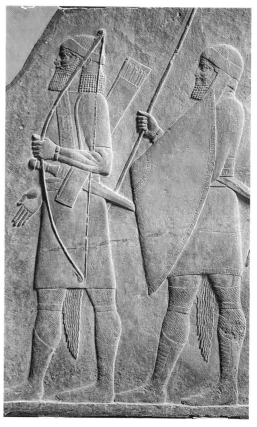

74 *above*. Prisoners, probably from Phoenicia or Palestine, playing lyres. From Sennacherib's palace, Nineveh, about 700 BC.

75 *above right*. Two soldiers in the bodyguard of Sennacherib (704–681 BC): the spearman on the right probably came from Palestine. From Nineveh.

Rather better grounded is the theory that men from Judah were drafted into Sennacherib's bodyguard. There is a series of large-scale sculptures, now split between London, Berlin and Mosul, which show a procession, with the king, crown-prince, courtiers, priests, musicians and guards. The guards are mostly typical members of the Assyrian army, but one of them 75 has, besides his spear and shield, the distinctive short kilt and turban with long ear-flaps that are worn by the defenders of Lachish. The Assyrians certainly did use foreign soldiers, and this must be one of them, either from Judah or somewhere else nearby, still wearing his native uniform.

Though one Biblical account of Sennacherib's campaign agrees that Hezekiah paid tribute as a result, another suggests that he was saved by divine intervention, a disaster in the Assyrian camp. A later anti-Assyrian intrigue may be reflected in the Biblical account of how Manasseh, son and successor of Hezekiah, was arrested and then released by the Assyrian king Esarhaddon; yet Esarhaddon's own records mention Manasseh as an obedient vassal. It was only about 627 BC, when the Assyrian grip was weakening, that the kings of Judah regained some freedom of action. Their poor judgement led ultimately to Nebuchadnezzar's sack of Jerusalem in 587 BC, and the incorporation of Judah into the Babylonian empire.

The Hunts of Ashurbanipal

Civilization had been hacked from the wilderness and wild animals were among the hostile forces from which a Mesopotamian king was obliged to protect his land. The most dangerous of these was the lion. The earliest monument to show a ruler killing lions dates from before 3000 BC, and the theme reappears again and again. Yet there seems to have been a gradual shift of emphasis, or maybe lions were never so numerous that they could be regarded as common vermin. So, by as early as 1750 BC or thereabouts, we encounter a situation in which, though lions are to be killed, only royalty is allowed to do the killing. There is one letter in which the writer enquires anxiously what he is to do about a lion trapped in the loft of his house; the lion was eventually caught in a cage and sent by boat to the town where the king was resident.

Sometimes the Assyrian kings kept tame 76 lions at court, but at the same time killing lions was a meritorious activity. Royal prowess, in this and other respects, was symbolized in the royal seal, which showed the monarch grasping and stabbing a lion that stood facing him, erect upon its hindlegs. This feat was genuinely possible because the Mesopotamian lion, now extinct, was smaller than the African variety with which we are most familiar today. There are well attested stories, from the nineteenth century, of the young Arab proving his worth by deliberately entering a lion's den; the animal's attention was attracted to the left arm, which was swathed in some protective material, and it was dispatched with a weapon held in the right hand. What had once been a royal prerogative and duty ended as a popular sport. Similarly the earlier Assyrian kings, or some of them, clearly enjoyed their lion hunts, and their annals recorded how many they had killed.

We have sculptures showing the hunting of lions from Ashurnasirpal's palace, but by far the largest number are those commissioned by Ashurbanipal for his own palace at Nineveh, built about 645 BC; he may even have revived the sport. One corridor there was decorated on both sides with large-scale lion-hunt scenes, combining high symbolism with Derby Day anecdote, which have been acclaimed, since their discovery, as the supreme masterpieces of Assyrian art. There is also a feeling that, because these sculptures show lions in agony, the 77 sculptor must have had some sympathy with his subject, and deserves our approval for his humanitarian approach. We might indeed imagine that the sculptor was cleverly pointing the contrast between the cruel king and his noble victims, but we should not forget that the people for whom these sculptures were designed saw the king as the paragon of nobility and the lions as cruel enemies who deserved a painful, even ludicrous, death. What the sculptures do 78 show is a sense of drama, and great power of observation coupled with skill in execution. Yet still someone, perhaps Ashurbanipal himself, thought he had noticed a mistake; virtually all the large-scale lions were originally carved with longer tails, which have since been systematically shortened.

Three compositions survive from this corridor Unlike traditional military narrative, where the action moves mainly in one direction, here it tends to converge towards the middle. The first composition shows Ashurbanipal's preparations 79 for the hunt. The next includes, to one side, a hill on the crest of which stands a small building or monument which is itself decorated with a

76 Lion and lioness in a garden. From Ashurbanipal's palace, Nineveh, about 645 BC.

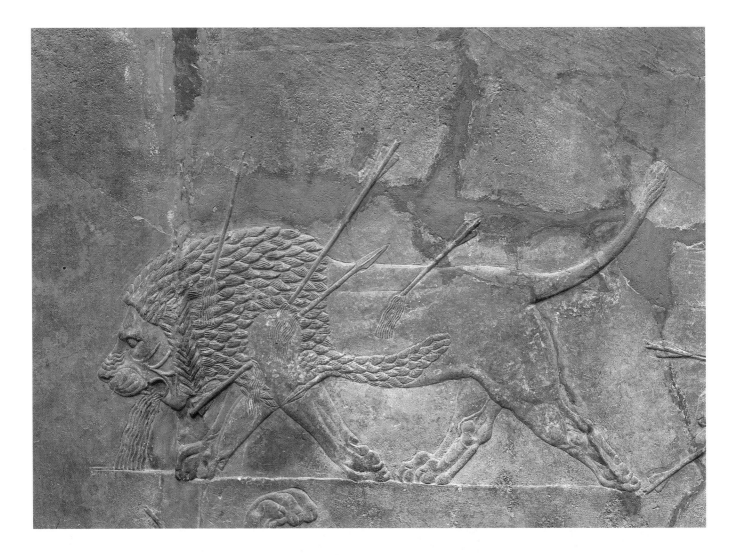

77–8 *above and above right.* Dying lion and lioness. From Ashurbanipal's palace, Nineveh, about 645 BC.

79 *below right.* Preparing for the hunt: Ashurbanipal reaches for his bow, while grooms struggle to harness the horses.

scene of the king killing lions from his chariot. Men and women are scrambling up the slope, either in terror or to reach a point with a good view of the action that is about to begin. For this is not, strictly speaking, a lion-hunt at all. The lions are not necessarily even wild. Instead they have been brought to the hunting-ground in cages, from which they are conveniently released one by one. There is one of these cages at the far right, with a trapdoor opened by a small child who has a miniature cage of his

own in which to hide. The hunting-ground is surrounded by a double line of soldiers in front of whom keepers, with mastiffs, stand ready to 81 drive back any lion that tries to escape; horsemen gallop to and fro. In the middle we see Ashurbanipal in his chariot, enjoying his sport. 82 Two guards beside the king deal with a wounded lion that springs at the chariot from behind. 80 Altogether there are eighteen lions or lionesses in this composition, though some of them must be represented more than once. Most of them

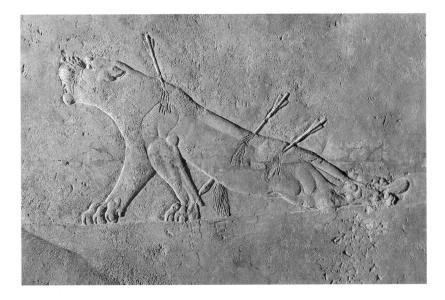

have been hit by arrows, and are dying or dead. There was a similar composition, with the king's chariot appearing twice, on the opposite side of the corridor. 83

A private gate-chamber in Ashurbanipal's palace was decorated with small-scale hunt scenes, arranged in three registers. In this room too, fallen from an upper storey, was found a second set of sculptures with similar subject-matter. Some of the incidents in the two sets effectively duplicate one another though they are not absolutely identical; for instance, the king normally wears his hat in the sculptures from the upper storey, whereas he only has his diadem in the gate-chamber. Some of the incidents are narrated episodically, with the same characters appearing at successive moments, as in a modern strip-cartoon. 85-6

An incident that occurs in both sets, which 84

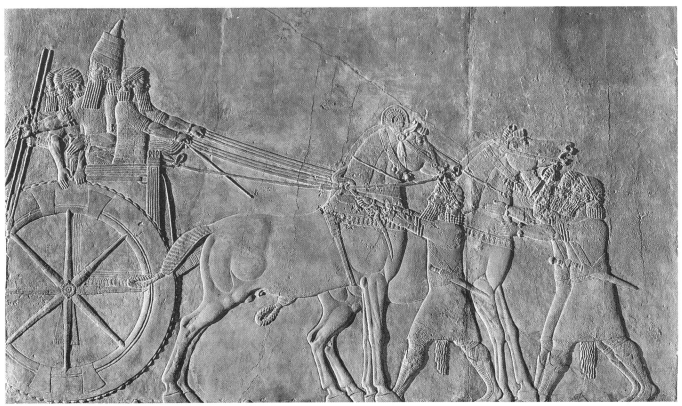

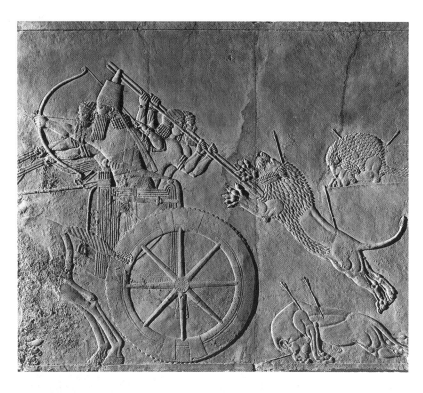

80 *left above*. The hunt in progress. The king shoots ahead, while two guards ward off a wounded lion. From Ashurbanipal's palace, Nineveh, about 645 BC.

81 *left*. A keeper with a mastiff, on the edge of the lion-hunt arena.

82 *above*. Ashurbanipal shooting: detail from fig. 80.

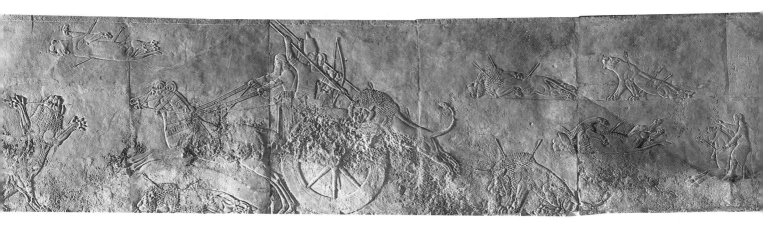

83 Another Ashurbanipal lion-hunt.

84 Three lion-hunt compositions, one in each register. At the top Ashurbanipal faces a lion released from a cage; in the middle he comes up behind a lion; and at the bottom he pours a libation over his victims.

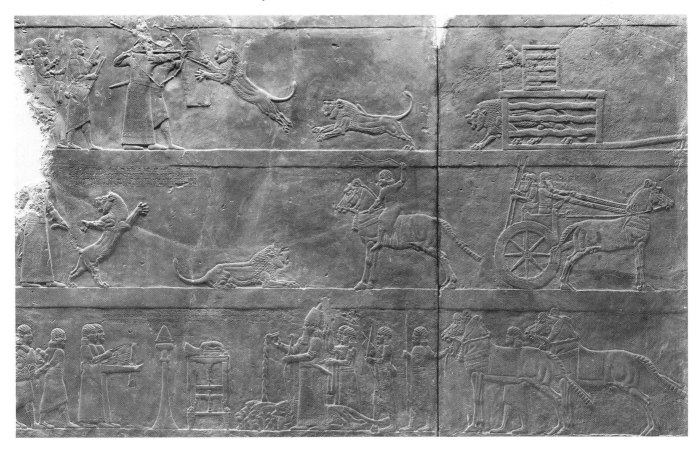

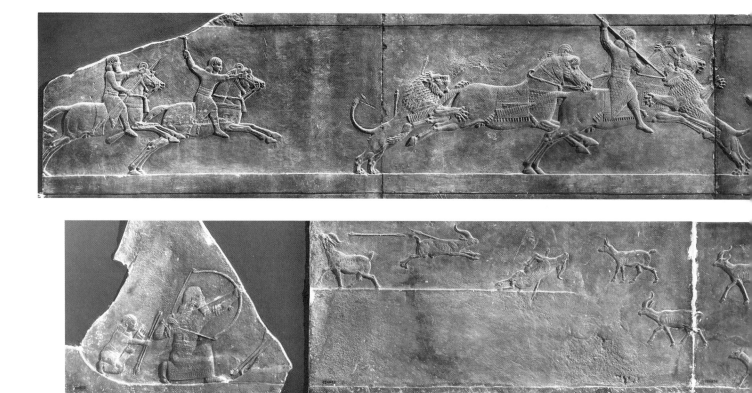

85–86 *top row.* An anxious
moment, as Ashurbanipal's
spare horse is attacked by a
lion that has been left for
dead. He himself is busy
with another, and his
attendants gallop
desperately to the rescue
from the far left. Here the
sculptor has used empty
space to dramatic effect, one
of the features that set
Ashurbanipal's hunt scenes
apart from the general run of
Assyrian sculpture. In the
next episode, however, to
the right, the king has coped
with the emergency. Some
courtiers exclaim at the size
of the two dead lions; others,
kneeling in disgrace, are
presumably the ones who
had allowed their horses to
lag behind.

complement each other, has Ashurbanipal on
foot, with a lion let out of a cage in front of him.
The lion leaps forward to the left, and an arrow
fails to stop him. He then jumps up at the king,
who shoots again while an attendant holds
the lion back with spear and shield. The next
scene shows the king thrusting his sword 87
through the lion's body. The lion is standing on
its hindlegs at this moment: it is the symbolic
act of the royal seal translated into reality. Yet
by this time the lion was already at death's
door; if it really stood, it must have been
because the king was holding it up. This
explains the absence, on the king's left arm, of
any protective material. It is not credible that
the king exposed himself to mauling, from a
slightly wounded but still vigorous lion, in the
way that this sculpture, viewed in isolation,
implies. In its true context, the scene can be
understood quite differently.

In another incident Ashurbanipal is dealing 84
with a lion that does not wish to fight. It is seen
lying on the ground, looking up at a horseman
who distracts it by waving a whip. In a second
scene the king, who has crept up from behind
and seized the lion by its tail, brings his mace
down on its head. This is explained in a
cuneiform caption. The slab to the left of this,
now in Paris, shows the king face to face with a
lion which he holds by the ear and kills with a
spear. Again this would seem an unacceptably
dangerous encounter, but it gains in credibility
if we suppose that the lion is already seriously
injured.

The lion-hunt from chariots was also repre-
sented in one of these small-scale sets of
sculptures, but the original slabs are lost. The
day's sport ends with a celebration and thanks-
giving. Courtiers carry in the dead lions, and 84
Ashurbanipal pours a libation of wine to

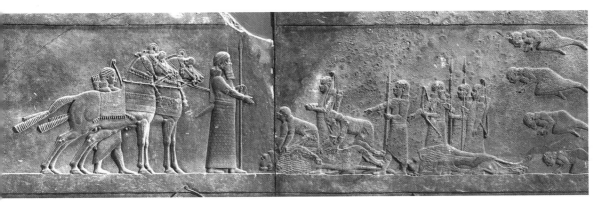

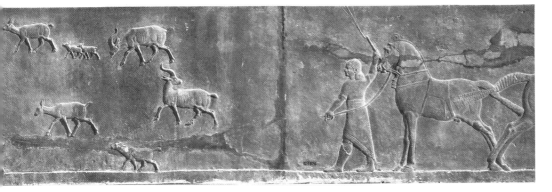

89–90 A beater, standing on the right beside his horse, alarms a herd of gazelle whose line of flight leads them to Ashurbanipal, hidden in a pit with bow and arrows.

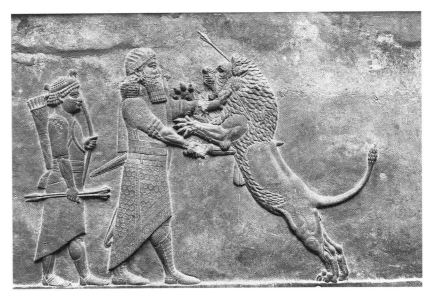

87 Ashurbanipal killing a wounded lion with his sword. This is the final episode, from a different version, of the composition in the top register of fig. 84.

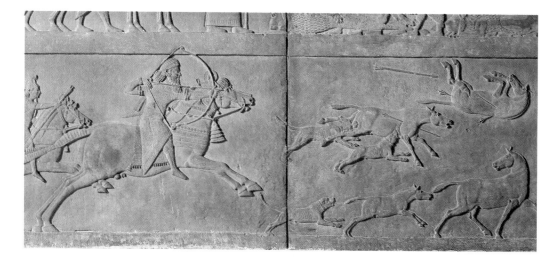

88 Ashurbanipal, with hounds, hunting wild asses; one of them turns to look back at a foal, which cannot run fast enough to escape. It is probable that a hunt like this was preceded by careful preparations, to ensure that the king found the herd without wasting too much of his time; accordingly this hunt scene led on to an ambush, shown further to the right, where more of the animals were killed or lassoed. Some may have been kept alive, and used in breeding a variety of mule.

Ishtar, goddess of battle. One attendant is playing a harp, and there are the usual cult fixtures: an incense-burner, and a table loaded with two joints of meat and a bunch of onions.

Not all lions were brought to the king in cages, and drawings of lost slabs show that on one occasion he hunted them in thickets beside a river. Less dangerous animals were certainly hunted in the wild, and these hunts too were represented in sculpture. Again, the hunt was meritorious, since herds of wild asses and 88 gazelle must have been extremely unwelcome in the fields of Assyrian farmers. Their presence was even regarded as synonymous with desolation: thus Ashurbanipal, after devastating the land of Elam later in his reign, boasted that they and other wild beasts were the only inhabitants he left. Nonetheless this kind of hunt did not have the same degree of symbolic importance, and the carvings showing it were confined to the lowest, least conspicuous register of decoration.

A technique employed with gazelle was for 89-90 the king to remain in ambush while beaters drove the animals towards him. One beater is seen at the right-hand end of the composition, standing by his horse and attracting attention to himself. The herd is peacefully grazing, but one of the animals looks round, and they will

shortly break into flight. The path they take leads them to a pit where the king is kneeling, alone but for a small boy who keeps him supplied with arrows. The leading gazelle pauses, receives an arrow through his chest before he can turn back, and is followed by an arrow in mid-air as he bolts and then collapses. This is another scene in which the sculptor has used empty space to intensify the drama.

It is perhaps worth recalling that these scenes of slaughter, like the military narrative of the Assyrian kings, show only one side of the story. The wild ass survived for Layard to see. There were lions in Mesopotamia into the twentieth century. Gazelle are said to have been common in Assyria as late as the 1950s, though now found only in the remotest corners of Arabia. It has taken modern fire-arms and motorized transport to complete Ashurbanipal's work.

Ashurbanipal at War

During the reign of Ashurbanipal several important states retained their independence beyond the borders of the Assyrian empire. On the east, in southern Iran, the kingdom of Elam lay uncomfortably close to Assyria's Chaldaean and Babylonian provinces; disturbances there frequently involved the Elamites and sometimes led to war. At the same time there was a constant temptation for the Assyrians to interfere in the complicated internal politics of Elam. By this time the Assyrian administration at Nineveh was keeping careful records, written and illustrated, of all major military expeditions, and we have an exceptionally detailed record of the Elamite wars.

The first probably happened in either 663 or 653 BC. At this time the Elamite king was Tepti-Human-Insushnak, a name conveniently abbreviated by the Assyrians, who spoke a different language, to Teumman. He had apparently come to power in 664, and the sons of the previous king went to Assyria as political refugees. Teumman requested their extradition, but the diplomatic exchange ended in insults. Consequently Ashurbanipal's army invaded Elam, and the campaign was illustrated in one of the rooms of his grandfather Sennacherib's palace. We know from cuneiform tablets, some of which list captions designed for this or a similar series of sculptures, that the campaign and its aftermath were shown in a cycle of some ten compositions. These were arranged in two registers, with the campaign itself below; above were the celebrations in Assyria. Later the same cycle of compositions, slightly modified, was reproduced on the walls of the palace which Ashurbanipal built for himself. The British Museum possesses parts of four of the earlier set of compositions, and at least one fragment from the second set, which is mainly known from drawings by William Boutcher. Within each composition, when appropriate, a series of separate episodes was represented individually, like an internal strip-cartoon.

The crucial Assyrian victory was at the battle of Til-Tuba. The greater part of this composition is preserved, with the main action moving from left to right. On the far left is the charge of the Assyrian army, chariots, cavalry, and helmeted infantry. A critical factor in the victory was probably the Assyrian skill at close-quarter fighting; the Elamites seem to have relied overmuch on bows and arrows. The enemy, most of whom can be recognized by their head-bands knotted at the back, are already giving ground. Some of them are running down a steep slope, presumably the mound of Til-Tuba on which they have been stationed. Further to the right the composition is divided into three 91 horizontal bands. The retreat turns into a rout, and the enemy are finally driven into the river behind them. For three days, according to Ashurbanipal, the river was choked with corpses. Against this general background of confused fighting, the fate of the Elamite king is recorded 92 in a series of episodes. Some are explained in captions carved on the stone, others in the tablets which refer to this cycle of sculptures.

To the right of the Til-Tuba composition, originally separated from it by a doorway, there is quite another scene. A cheerful procession of people, including musicians, is emerging from 93 an Elamite city on the right. They are coming to greet Ummanigash, one of the refugees whom Ashurbanipal has appointed as their new ruler; he arrives from the left, in the second row up, and is identified by a caption just above his 94 head. An escort of Assyrian troops follows him, and he is introduced to his subjects by an Assyrian adviser, who holds him firmly by the hand. Meanwhile, in the river below, dead men, horses and chariots float downstream among the fish. As is usual in Assyrian art, the things in the water are shown as the artist knew them to be, rather than half-submerged as they would have appeared to the eye-witness.

The register above the installation of Ummanigash shows one of the celebrations in Assyria that followed the war. The Elamites themselves had been treated honourably, since Ashurbanipal's quarrel had been with Teumman and there was no question of the inhabitants having broken faith. It was quite another matter for some tributary Chaldaeans who had allied themselves with Teumman, and their leaders appear on the left, being executed in a variety of

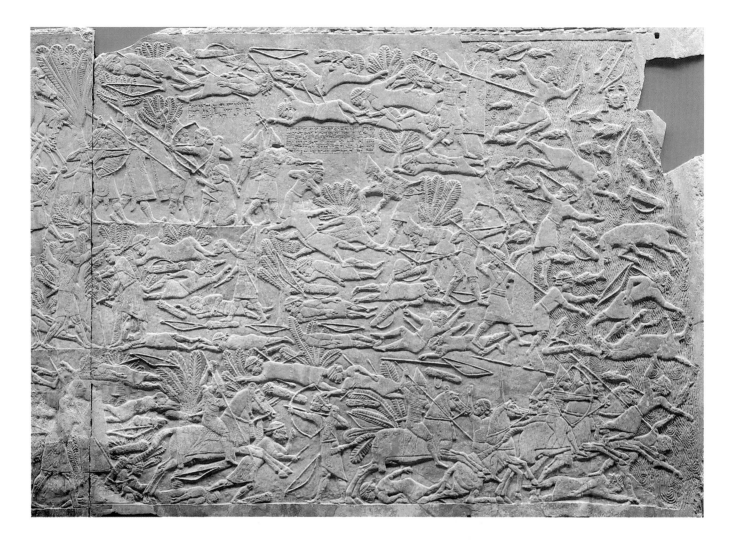

ways. Among the men standing, just to the right, is another captive who has been forced to wear Teumman's head on a rope round his neck. A fine horse, on the right-hand side, belongs to a chariot in which Ashurbanipal stood looking on, and in front of the grooms at the horse's head are a pair of Elamites, facing left and wearing their distinctive national headgear. These two are Teumman's ambassadors, who had been sent to Assyria with the insulting 95 message before the outbreak of war. They are obliged to show Teumman's letter to another

91 The battle of Til-Tuba, with the Assyrians driving the Elamites into a river. A sculpture of Ashurbanipal, from Sennacherib's palace, Nineveh, about 660–650 BC.

92 *above right*. A detail from the battle of Til-Tuba. The Elamite king, Teumman, is trying to escape, but his chariot crashes. He falls out, under a wheel, while his horses panic and twist to and fro. Further down, slightly to the right, he hurries away with an arrow in his back, supported by his son.

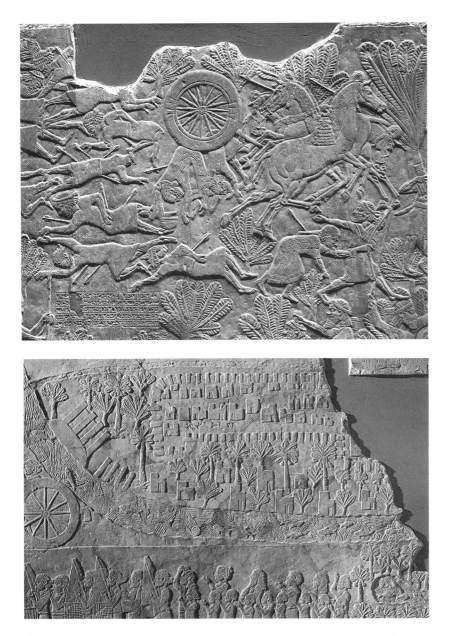

93 The Elamite city of Madaktu. From Nineveh, about 660–650 BC.

pair of ambassadors, short men in tasseled caps, who have come from Assyria's northern neighbour, Urartu. The same Urartians reappear as spectators in the execution scenes to the left, and it seems that the Assyrians were anxious to discourage the king of Urartu from making the same mistakes as Teumman.

The battle of Til-Tuba failed to solve the Elamite problem. Ummanigash was eventually murdered, and his successors meddled in the affairs of Babylonia which was then ruled by Shamashshumukin, one of Ashurbanipal's brothers. Shamashshumukin revolted against Assyria during 652–648 BC, and one consequence was another series of Assyrian campaigns against Elam.

Two events from one invasion are recorded in a series of sculptures from one room of Ashurbanipal's palace. Some slabs from the series are lost, but were recorded in early photographs and drawings. The panelling was again divided into two main registers, each of which was subdivided at some points. The action in the upper register ran from left to right, with a composition similar in principle to that of Sennacherib's siege of Lachish. On the left there is the Assyrian attack. Then, between plain niches, we see the Elamite city of Hamanu, 96 with defenders still resisting though some of them are falling from the walls, one losing his headband in the process; a slab from another series shows the same city, drawn somewhat differently, after capture. Next, while some Elamites are attempting to hide in a clump of reeds, most of them are being deported, marching to the right where the Assyrian king is represented receiving them. There are the standard homely touches: a child riding on its father's back, two women feeding their babies 97 at the breast. The lower register had a very similar composition, but here the action ran from right to left: the city under attack is missing, while what survives includes the front of the procession approaching the king.

Shamashshumukin, the ally of the Elamites, failed in his revolt, and Ashurbanipal's forces captured Babylon in 648 BC. This event was represented in Ashurbanipal's throneroom,

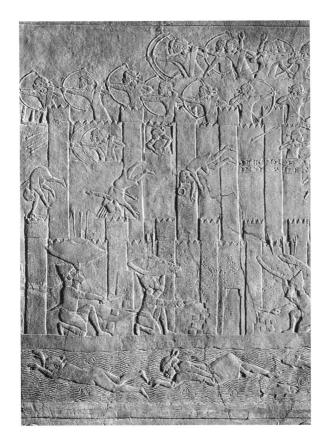

which was decorated with a wide-ranging selection of illustrations from his principal campaigns. Two slabs that survive show the Assyrian king inspecting the booty of Babylon while prisoners stream past; notable items include the regalia of Shamashshumukin, who had had the good sense to kill himself before capture. Ashurbanipal and his immediate com- 98 panions in this sculpture are conspicuously larger in scale than the other figures, and Ashurbanipal himself is normally a little taller than anyone else; this mannerism, sometimes

94 *below.* An Assyrian officer, after the battle of Til-Tuba, introduces a new king to the Elamites of Madaktu.

95 *left below.* Two Elamite ambassadors, on the right, with head-bands and long robes, being introduced to two Urartian ambassadors, on the left, with caps. From Nineveh, about 660–650 BC.

96 *left.* Assyrians attacking the Elamite city of Hamanu. From Ashurbanipal's palace, Nineveh, about 645 BC.

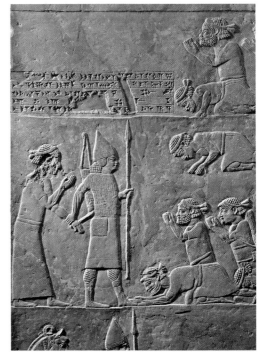

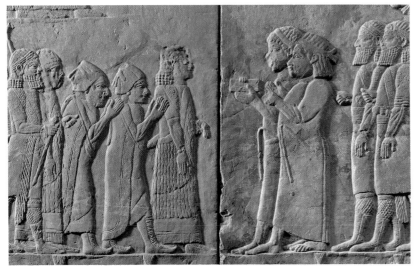

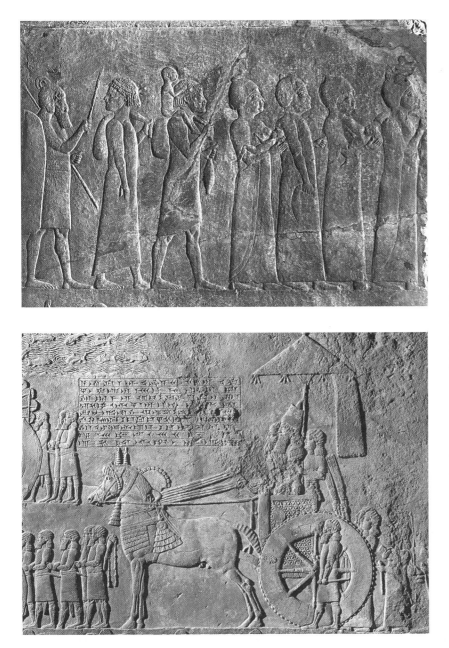

97 *top*. Elamite prisoners from Hamanu.

98 Ashurbanipal inspecting the booty of Babylon. About 645 BC.

called social perspective, is rare in Assyrian sculptures made before Esarhaddon's invasion of Egypt, and may have been adopted from Egyptian art. Above the Babylon scene, in a higher register, there was the sack of an Elamite city, perhaps the capital, Susa, which fell in 647 BC. Among the items of booty in this scene are colossal figures of bulls on carts, which are mentioned in Ashurbanipal's annals.

The successive invasions had a disastrous effect on Elam, and there were several contenders for the throne. The man who was king when Susa fell took refuge in the mountains of Iran but was handed over to an Assyrian emissary. Ashurbanipal eventually collected no less than three Elamite ex-kings who were employed, together with one Arab, to pull his wheeled throne at Nineveh during a great festival of the goddess Ishtar. Fragments of sculpture, from a series showing this or some similar celebration, include Elamite soldiers beside Assyrians, wearing like them a festive feathered head-dress. The last we see of the Elamite kings is at a garden-party in Assyria. Two of them, still in their round royal hats and 101 long robes, are obliged to act as servants. One carries a jar and the other a fly-whisk. Assyrian courtiers hustle them with fly-whisks, or throw themselves at their feet in mock obeisance.

This same composition continues to the right, with further courtiers and musicians, towards Ashurbanipal himself. The scene is set idyllically in a garden on the outskirts of Nineveh, 102 enclosed at the far right by a screen. There are palm-trees, pines, and a trellised vine, and birds in the branches; Teumman's head, a souvenir from Til-Tuba is fastened to one of the trees. Ashurbanipal reclines on a sofa with a flower in one hand and a bowl in the other; his sword, bow, and quiver rest on a table to the right, as he has just been shooting, and a massive necklace, possibly symbolic of dominion over Egypt, hangs from the head of the sofa. His queen sits facing him on a throne. The furniture 103 is elaborately carved with types of decoration reminiscent of that on earlier ivory furniture that has been found at Nimrud. There seem to have been scenes of hunting in a lower register

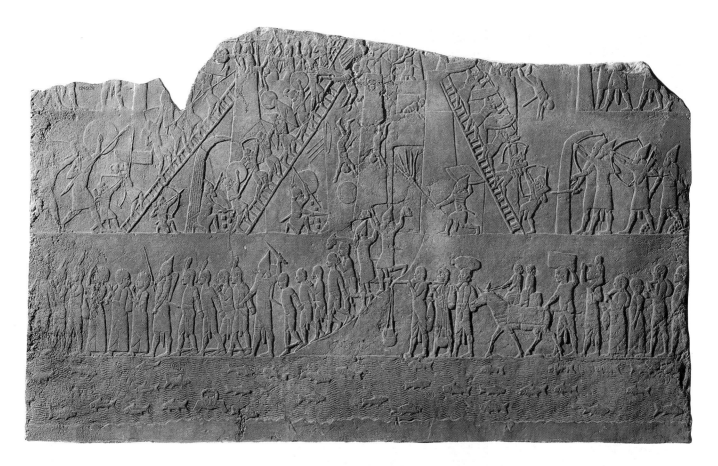

99 The Assyrian army attacking a town in Egypt. From Ashurbanipal's palace, Nineveh, about 645 BC.

of this slab, and it was probably part of a series, including both hunting and military narrative, which decorated one of Ashurbanipal's private apartments. The picnic was the culmination or focal point of a decorative scheme incorporating everything of which Ashurbanipal was most proud.

While the king was celebrating his achievements, however, the Assyrian state was as vulnerable as ever. The throneroom sculptures may have shown conquests as far away as Egypt in the west, but the Assyrians never 99 controlled that country for long. On the southern borders of the empire there were nomadic Arabs, always ready to take advantage of weak- 100 ness in the central government organization, and more nomads, Cimmerians and Scythians,

had appeared in the mountains of the north. To the east the Medes and Persians were increasingly aggressive. The Chaldaeans, after all their reverses, were about to take over Babylon.

The Assyrian empire took about twenty years to fall apart. It seems probable that Ashurbanipal in the hope of avoiding yet another disputed succession, appointed his son Ashuretelilani as joint ruler with himself a few years before he died in 627 BC. Nonetheless there was a civil war which ended with Sinsharrishkun becoming king about 623 BC. By then the outlying provinces may already have been lost, and by 616 BC Sinsharrishkun was in the humiliating position of having to call for Egyptian support against Babylon. In 614 BC the Medes invaded Assyria, and succeeded in capturing and sacking Ashur;

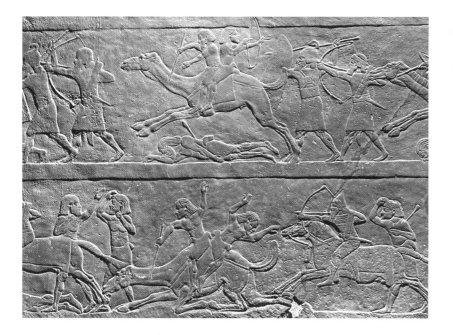

100 Assyrian troops pursuing Arabs. From Nineveh, about 645 BC.

101 Elamite kings forced to act as servants at Ashurbanipal's court. From Nineveh, about 645 BC.

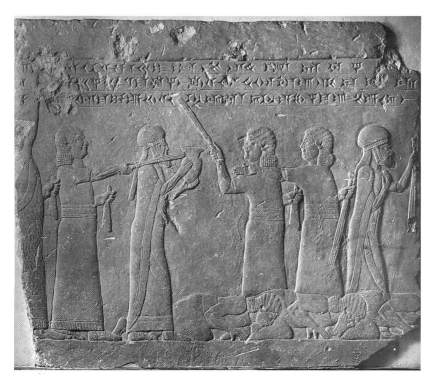

they formed an alliance with Babylon, and Nineveh fell in 612 BC. A last Assyrian king, Ashuruballit, taking the name of one of his most illustrious forebears in the distant past, rallied the west but did not last for more than a few years. Babylon became for a while the chief city of the Middle East.

Today much of Nineveh is a flourishing suburb of Mosul, but there are places, not so far away, where little has changed since the days of Claudius Rich. In autumn, after a few months without rain, Assyria may seem a dusty brown desolation, but in spring it is paradise. The air is brisk, the last snow glimmers on the mountains of Kurdistan, you can wade knee-deep through grass and wild flowers as variegated as a Persian carpet. The people of Mosul, like Ashurbanipal 2650 years ago, go out and picnic in the countryside, by the waters of Nineveh. 104

104 *left*. Shallalat, one of Sennacherib's weirs, near Nineveh: now restored, and a favourite picnic spot for the people of Mosul.

102 *below*. Ashurbanipal and his queen drinking, to the sound of music, in a garden on the outskirts of Nineveh. From Ashurbanipal's palace, Nineveh, about 645 BC.

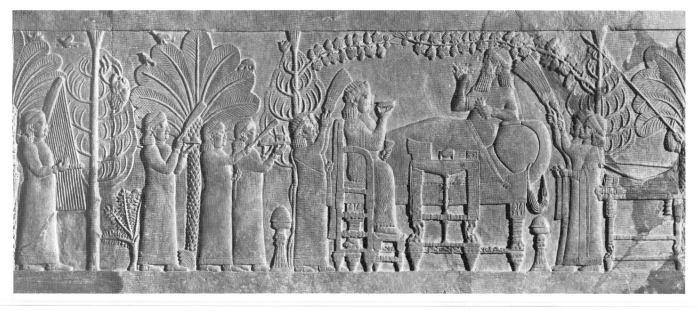

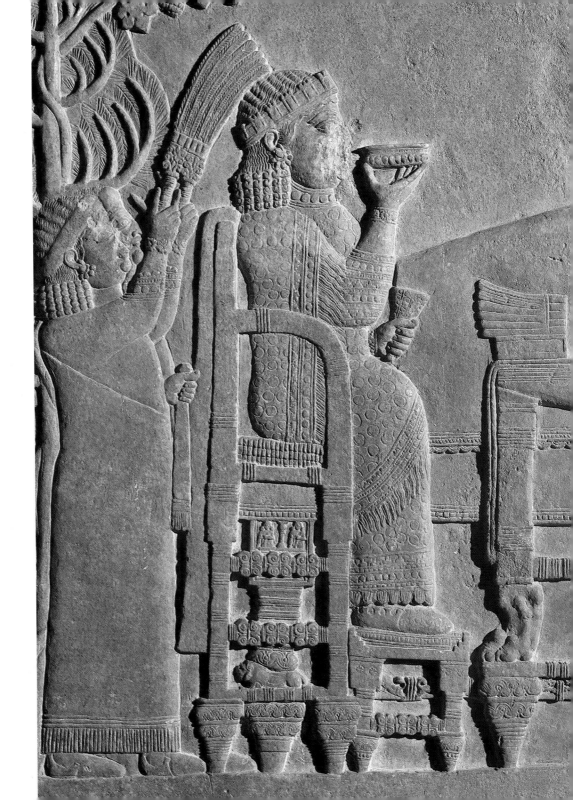

103 The Queen of Assyria, about 645 BC: detail from fig. 102.

Key to Illustrations

Further reading

BARNETT, R.D.
Sculptures from the North Palace of Ashurbanipal
London 1976

BARNETT, R.D., and FALKNER, M.
The Sculptures of Tiglath-pileser III
London, 1962

CAMBRIDGE ANCIENT HISTORY, Vol. 3
Cambridge, 1925, 1982

GADD, C.J.
The Stones of Assyria
London, 1936

GRAYSON, A.K.
Assyrian Royal Inscriptions, Vol. 2
Wiesbaden, 1976

GROENEWEGEN-FRANKFORT, H.A.
Arrest and Movement
London, 1951

LAYARD, A.H.
Nineveh and its Remains
London, 1849

MADHLOOM, T.A.
The Chronology of Neo-Assyrian Art
London, 1970

MOORTGAT, A.
The Art of Ancient Mesopotamia
London, 1969

OLMSTEAD, A.T.
History of Assyria
New York & London, 1923

OPPENHEIM, A.L.
Ancient Mesopotamia
Chicago, 1964

PALEY, S.M.
King of the World
New York, 1976

PARROT, A.
Nineveh and Babylon
London, 1961

POSTGATE, J.N.
The First Empires
Oxford, 1977

PRITCHARD, J.B. (ed.)
Ancient Near Eastern Texts
Princeton, 1969

RASSAM, H.
Asshur and the Land of Nimrod
New York & Cincinnati, 1897

NOTE: this list gives a selection of books written in English. Detailed studies of Assyrian sculpture appear in periodicals such as *Iraq* and *Baghdader Mitteilungen*.

105 Trees by the Tigris near Nineveh, about 700 BC. From Sennacherib's palace.

Kings of Assyria 1132–609 BC

NOTE: a few dates are uncertain, but errors are unlikely to exceed one or two years. Overlaps indicate joint or rival reigns.

Index

Figure numbers appear in bold type